The Campus History Series

CLEMSON UNIVERSITY

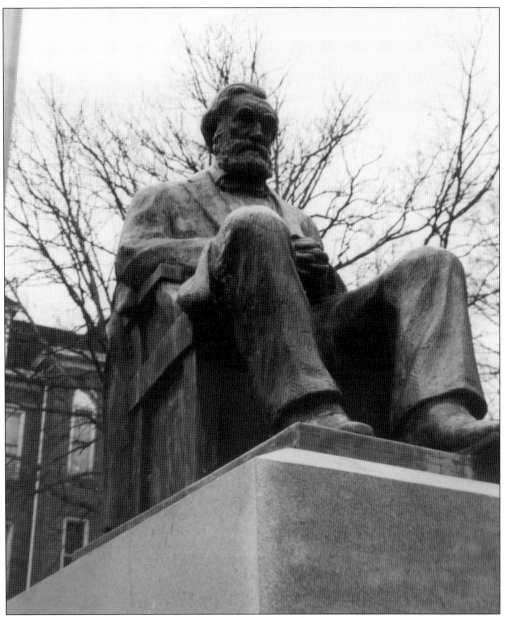

Thomas Green Clemson (1807–1888), the university's founder, came to South Carolina in 1838 when he married Anna Maria Calhoun, the daughter of South Carolina's famous statesman John C. Calhoun (1782–1850). Born in Philadelphia and educated both in Europe and in the United States, Clemson's vision for the recovery of South Carolina's economy destroyed by the Civil War was based on education and the reform of agriculture. In his will, dated November 6, 1886, he wrote, "Feeling a great sympathy for the farmers of this State, and . . . believing that there can be no permanent improvement in agriculture without a knowledge of those sciences which pertain particularly thereto, I have determined to devote the bulk of my property to the establishment of an agricultural college upon the Fort Hill place." In November 1889, Governor Richardson signed the bill accepting Thomas Green Clemson's gift for the establishment of the Clemson Agricultural College, which formally opened in July 1893 with an enrollment of 446 students.

The Campus History Series

CLEMSON UNIVERSITY

HELENE M. RILEY

ARCADIA
PUBLISHING

Copyright © 2002 by Helene M. Riley
ISBN 978-0-7385-1470-3

Published by Arcadia Publishing
Charleston, South Carolina

Printed in the United States of America

Library of Congress Catalog Card Number: 2002108889

For all general information contact Arcadia Publishing at:
Telephone 843-853-2070
Fax 843-853-0044
E-mail sales@arcadiapublishing.com
For customer service and orders:
Toll-Free 1-888-313-2665

Visit us on the Internet at www.arcadiapublishing.com

Dedication
The best educational institutions are governed by the principles of intellectual curiosity paired with integrity, by a spirit of scientific inquiry, and by a desire to impart the acquired knowledge to others. Little more than a century ago, Thomas Green Clemson's dream for South Carolina provided the means for dedicated individuals and fertile minds to pursue their goals of learning and sharing that shaped Clemson University in the 20th century.

At the dawn of the new millennium, our state and nation again face new and formidable challenges, and another leader has emerged from within the Clemson family to become the university's 14th president. James F. Barker's vision for higher education in the 21st century places Clemson "among the nation's top 20 public universities." It is a daring and ambitious goal. This book is dedicated to Jim Barker, and to his success in reinterpreting Thomas Green Clemson's wish for "a high seminary of learning."

By reflecting on our past,
we shape the present,
and without past and present,
there is no future.

Contents

Acknowledgments		6
Introduction		7
1.	From Concept to College	9
2.	The Early Years	21
3.	Educating South Carolina	41
4.	Running the Show	61
5.	A Time of Transition	83
6.	The Roaring Fifties and the Winds of Change	103
Epilogue		126
Bibliography		127

Chapters 1-4 will be in Essay 1

ACKNOWLEDGMENTS

Many people have contributed to this pictorial history of Clemson University and without their collegial assistance, this book could not have been created. I am deeply indebted to Marcia Barker who took time from her busy schedule to select and print images from the collection of the College of Architecture, and to Dr. Peter Lee, who selected photos and provided a history of architecture as a discipline at Clemson College. Dr. Cecil Godley and Dr. Ab Snell, both former directors of the Agricultural Experiment Station, selected and identified a bevy of photos. Dr. Snell procured a carton of vintage pictures not generally known to exist and graciously contributed its contents. Dr. Douglas Bradbury, professor of engineering, selected significant photos, annotated them, and made them come alive with stories about the individuals they depict. Alumna Dolores Yoke and her husband, alumnus William E. Yoke, shared pictures and stories from the 1960s *Chronicle*, highlighting Clemson's change to co-education. Dr. George William Koon divulged the existence of an album with vintage photos of the English department faculty, and his colleague Prof. Frank Day offered valuable insight, advice, and reminiscences. Prof. Clifton "Chip" Egan provided a CD with early scenes from Clemson theatre productions, and Prof. Lillian "Mickey" Harder, director of the Brooks Center for the Performing Arts, shared posters of musical productions from the 1960s and beyond. Tim Bourret, assistant athletic director, and former soccer coach I.M. "Coach" Ibrahim gave liberally of their time and considerable resources to provide me with sports photos, information, and statistics.

Special thanks are due to Michael Kohl, head of the special collections library, and his always cheerful and courteous staff, who helped in ever so many ways with the photo selection process, expert information, and technical expertise; and to Dr. Julius R. Earle, who proofread chapter five. This book could not have been produced without the skilled assistance of Sajay Sadasivan, graduate student in industrial engineering, who spent many evening, weekend, and holiday hours scanning the selected pictures to publisher's specifications. Artisans of his caliber and work ethic are hard to find.

I am also grateful to Deans Thomas M. Keinath and Jerry E. Trapnell; Dr. Christian Przirembel, VP for research; and John W. Kelly, VP PS&A, for their advice and support. Many others, among them Cathy Sams and Liz Newall, helped me find and acquire specific photographs needed for this book. My gratitude goes above all to President James F. Barker, who has fully supported this and several of my previous scholarly endeavors.

INTRODUCTION

From the beginning, Thomas Green Clemson's plan for an agricultural and mechanical college faced an uphill battle. The Morrill Act, providing funds from the sale of each state's public lands for the support of college-level instruction in agricultural and technical subjects, was vetoed in 1857 by President Buchanan. When President Lincoln signed the measure in 1862, the land-grant movement gained new impetus, but it still lacked popular support. Clemson's defense of the Confederacy took him to Shreveport, Louisiana, during the Civil War as first lieutenant of the Nitre and Mining Corps, C.S.A., with scientific and advisory duties. Upon his return, he was more convinced than ever that scientific knowledge was the key to rebuilding South Carolina's economy. In 1866, as president of the Pendleton Farmers Society, he helped write a circular soliciting contributions for a school of science. Although that effort failed, he continued to write for scientific journals, and to give public talks on the need for practical education for farmers and artisans in the trying years of Reconstruction. Others began to share his interest, but progress was slow.

Not to be defeated, Clemson planned with his wife Anna to leave Fort Hill to the state for the founding of a scientific institution, and when she died in 1875, he inherited her share of the plantation as well. For much of the rest of his life Clemson worried about the realization of his planned legacy. Uneasy with his will drafted by James H. Rion in 1883 and providing for a "Fort Hill Scientific Institute," he consulted professionals in three key areas in the fall of 1886. They were Daniel K. Norris of the Farmers' Association, the attorney Col. Richard W. Simpson, and Benjamin Ryan Tillman of Edgefield, the colorful and radical leader of the farmers' movement, who was elected governor in 1890. With Simpson's assistance, Clemson rewrote his will in 1886 with a codicil in 1887. Together they form the final document, changing the institution's name to "Clemson Agricultural College of South Carolina."

Still, the battle was not won. Clemson's will elicited much controversy and encountered much opposition. When he died in 1888, his estate was appraised at $106,179.61, not including 39 oil paintings, 9 family portraits, and a bevy of books and maps that were not assessed. Some personal items and $15,000 were willed to Clemson's granddaughter Floride Isabella, most of the rest to the state. This included Fort Hill's 814 acres and approximately $80,000 in cash and securities. Floride's father, Gideon Lee, believing that his daughter had been shortchanged, contested the will in court. Opposition to the document came from many other quarters as well. The South Carolina College, recipient of the federal funds from the Morrill and Hatch Acts for its agricultural and mechanical program, fought hard to retain the money in Columbia. Tillman insisted that the institution turned out "book farmers," and he advocated the establishment of a separate agricultural and mechanical college with an experiment station and scientific institutes

for farmers. Friends of South Carolina's established denominational colleges and The Citadel in Charleston also feared the competition for funds and potential cadets. Others disliked the proposed college's majority of life trustees on its board, thereby minimizing state control. The fight was on and victory was not to come easily.

John P. Richardson's election as governor in 1886 was a setback for Tillman forces and the agricultural college that Clemson wanted. In 1887, the new legislature acted to expand the South Carolina college into a university and permitted the addition of an agricultural experiment station to its agricultural and mechanical program. Therefore, when Thomas G. Clemson died in April 1888 and his gift of money and land suddenly became available to the state, Tillman was thrilled that "fortune has unexpectedly smiled on us in the munificent bequest of Mr. Clemson." Shortly after the will was probated, the seven life trustees met on May 2, 1888 under a great oak on the lawn of Fort Hill, accepted their positions as trustees, and elected temporary officers before adjourning.

The acceptance or rejection of Clemson's legacy then became the most hotly debated issue in South Carolina politics. On Christmas Eve 1888, the joint House and Senate met to ratify the act accepting Thomas G. Clemson's bequest to the state, thereby establishing the Clemson Agricultural College. Governor Richardson declined to sign the bill before Gideon Lee's challenge of the legacy was resolved. Only after the U.S. Circuit Court of Appeals ruled in May 1889 that the will was valid did the governor sign it into law, waiting until November 1889 to do so. Tillman's victory on the issue made Clemson's wish a reality and helped Tillman win the governorship the following year. Funding for the college's building and maintenance was provided by the legislature with federal funds from the Morrill Acts of 1862 and 1890, the Hatch Act of 1887, a one-time appropriation of $15,000 by the general assembly, and annual appropriations derived from the tax on fertilizers. The state penitentiary was authorized to furnish convict labor to the college. The Clemson Agricultural College of South Carolina was born.

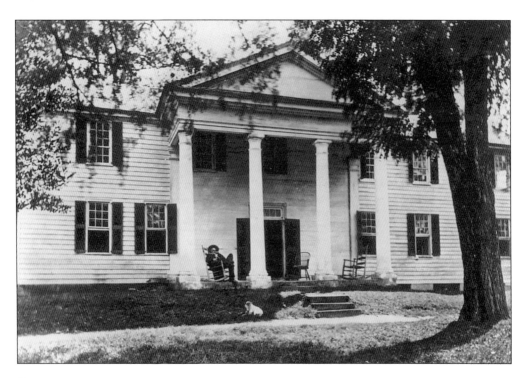

One

From Concept to College

Clemson's basic charter, the will of Thomas Green Clemson, provided for permanent leadership of the college by seven lifetime trustees with the right to fill vacancies in their own number, and by six trustees provided through "appointment or election" by the legislature. By giving the life trustees a majority, direct state control of the college was prevented. At the same time, a conservative continuity seasoned with political change assured progress and diversity within unity. The individuals chosen by T.G. Clemson for the initial board of trustees were R.W. Simpson, D.K. Norris, M.L. Donaldson, R.E. Bowen, B.R. Tillman, J.E. Wannamaker, and J.E. Bradley.

The founder's master plan was also a blueprint for connecting the present with the past while looking toward the future. The symbol of this nexus was the Fort Hill mansion located in the heart of the campus: a reminder of the past, safe haven in the present, and an invitation to new possibilities. In providing the means for its upkeep, Clemson wrote the following:

> It is my desire that the dwelling house on Fort Hill shall never be torn down or altered, but shall be kept in repair, with all the articles of furniture and vesture which I hereinafter give for that purpose, and shall always be open for the inspection of visitors.

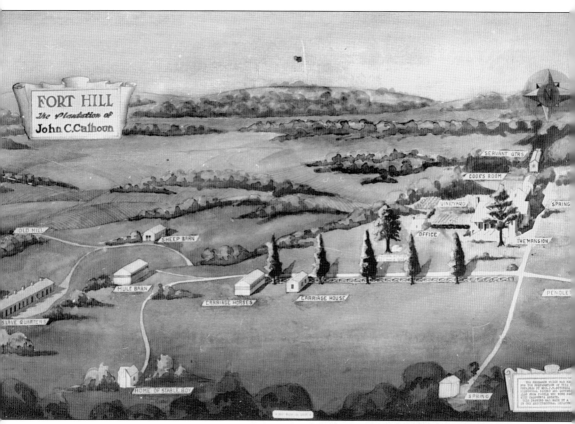

The Calhoun Plantation, in itself a monument to the antebellum South, is a fitting anchor in the past. This watercolor, carefully researched by Mrs. J.H. Mitchell and drawn by a student of architecture, shows the layout of the plantation, complete with slave cabins and John Caldwell Calhoun's office. In 1810, South Carolina's foremost statesman was elected to the congressional seat from the Abbeville district, and on January 8, 1811, he married Floride Bonneau Colhoun. The Calhouns had 10 children. Calhoun served as secretary of war from 1817 to 1825 during James Monroe's administration. Elected as vice president in 1824, he served with President John Quincy Adams. He was re-elected as vice president in 1828 and served with President Andrew Jackson. He resigned from the vice presidency in 1832 to begin a career in support of states' rights with his election to the United States Senate. From 1844 to 1845, he served as secretary of state under President John Tyler, then returned to the senate until his death in 1850.

Anna Maria Calhoun (1817–1875) was the fourth child of the Calhouns. The well-educated young woman met Thomas Green Clemson while visiting with her father in Washington. They were married on November 13, 1838 at Fort Hill, where three of their four children were born. Anna Maria's portrait, showing her in her court dress, was painted during the couple's stay in Europe. Her detailed inventory and description of the mansion's contents are an invaluable historical document.

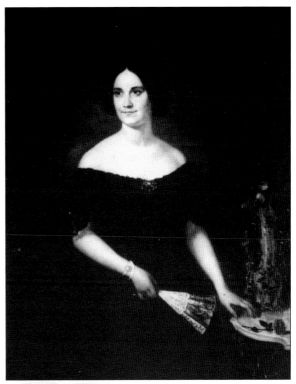

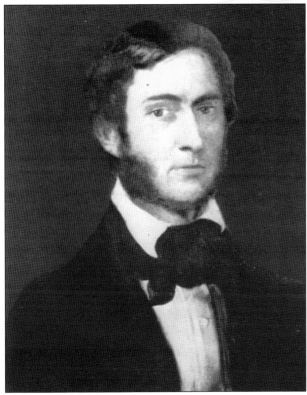

Thomas Green Clemson was the son of a wealthy Philadelphia Quaker. The irony of a man with a pacifist family background marrying the favorite daughter of a former secretary of war cannot have escaped his generation's attention, but Clemson was a fitting suitor for Anna Maria. His literary, artistic, musical, scientific, and multilingual education and talents made him an accomplished "Renaissance man." This self-portrait shows his considerable skill as a young artist.

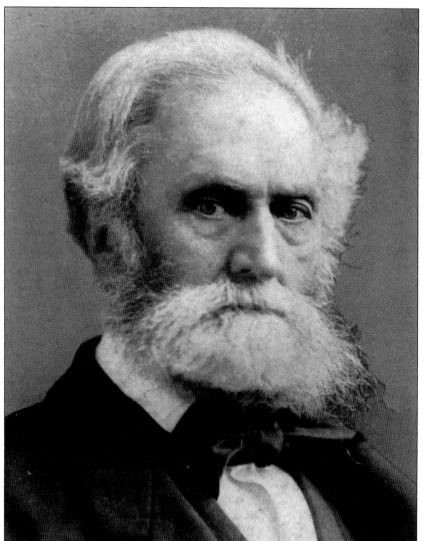

Clemson, shown here around 1885, could look back upon a life rich in personal achievement, service, and hard work. At age 19, his interest in chemistry took him to the Sorbonne and the Royal School of Mines in Paris. In 1831 the Royal Mint of France awarded him a diploma as assayer. This document was placed in the cornerstone of Clemson College's administration building in 1891. Between 1832 and 1839, Clemson wrote numerous scientific articles and was a consulting mining engineer in Paris, Philadelphia, and Washington. After his marriage, he managed Fort Hill plantation, oversaw the Calhoun Gold Mine in Georgia, and purchased a large plantation in Edgefield District. In 1844, President Tyler appointed Clemson chargé d'affaires to Belgium. There he earned the personal friendship of the Belgian King and was awarded the decorations of the Order of Leopold and the French Legion of Honor. After his return to the United States in 1852, he purchased a farm in Maryland and continued his experiments in agricultural chemistry. Clemson was instrumental in establishing the Maryland Agricultural College in 1856. At the Smithsonian he lectured on *Chemistry Applied to Agriculture*, and in 1860, Secretary of the Interior Jacob Thompson appointed Thomas G. Clemson as the first United States superintendent of agricultural affairs. He resigned this post in March 1861, submitting an extensive report on the *Advocacy of Agricultural Education* to the Patent Office.

Thomas Green Clemson owned property and investments both in northern and southern states, but he was sympathetic to the impact of the unfolding events on the labor-intensive agriculture of the South. His son, John Calhoun Clemson, enlisted in the Confederate army in 1861, was captured in 1863, and spent the remainder of the conflict in federal prison at Johnson's Island. Thomas Clemson joined the Confederacy in 1863 and served as a civilian in charge of the Nitre and Mining Bureau of the Trans-Mississippi Department until the war ended. The first page of his will declares his famous sentiment: "believing that there can be no permanent improvement in agriculture without a knowledge of those sciences which pertain particularly thereto, I have determined to devote the bulk of my property to the establishment of an agricultural college upon the Fort Hill place." The last page shows that it was admitted to probate on April 20, 1888 and recorded in Will Book pages 234–244.

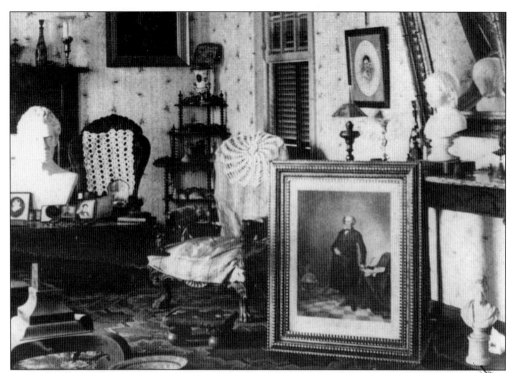

Although the Clemsons had made their home at a number of places in both the United States and Europe, they moved permanently to Fort Hill in 1872, after the death of the last of their four children. Mrs. Clemson liked a Victorian décor, and she displayed in her home souvenirs and gifts from their travels. This picture shows a collection of items for display, including an étagère and heirloom lacework.

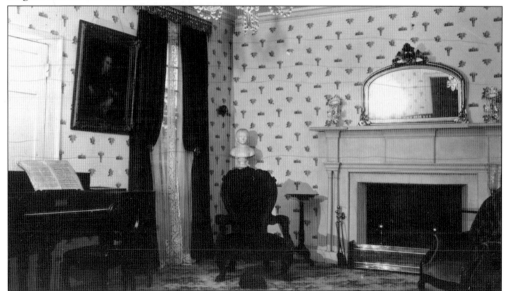

In addition to the official appraisal of Clemson's estate, the home contained four dozen oil paintings and family portraits, numerous books, and a bevy of maps. This formal picture of the parlor shows Anna Maria Clemson's square grand piano, which she played proficiently.

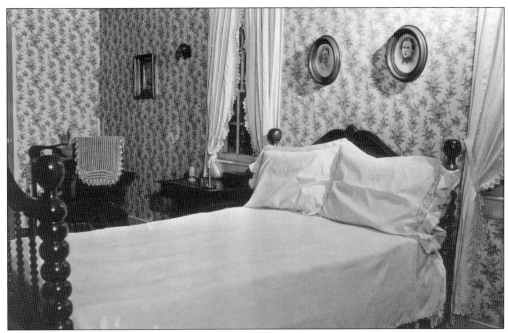

In contrast to the living and entertaining areas of the mansion, the bedrooms are small, and some even cramped. Note the washbasin and water pitcher—a welcome means to freshen up. The Clemsons had three daughters and one son. Both an infant daughter who died in 1839 and Floride Elizabeth (1842–1871) were born at Fort Hill. Cornelia Clemson, their fourth child, died in 1858.

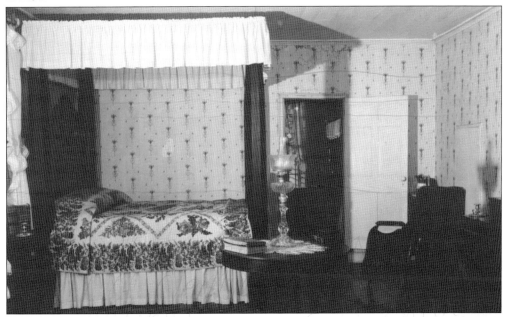

The massive poster bed, reading lamp, and books give this bedroom a more masculine context. John Calhoun (1841–1871), the Clemson's only son and a captain in the Confederate army, was also born at Fort Hill. He died of injuries received in a train wreck. John and his sister Floride, who died of a lingering illness at age 29, were buried 17 days apart in the summer of 1871.

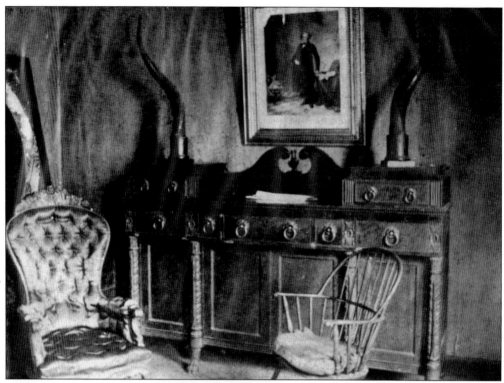

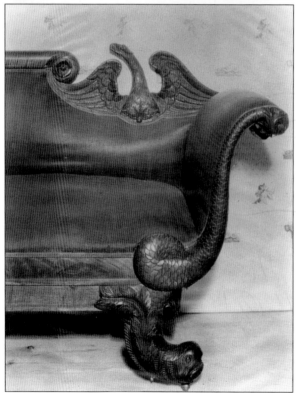

The entertaining areas also offered an opportunity to display treasured gifts. The two large horns on the antique sideboard were a gift to John C. Calhoun from Stephen Decatur. Honored in 1815 at a banquet, the famous naval commander proposed the following toast: "Our country! In her intercourse with foreign nations may she always be in the right; but our country, right or wrong!"

This magnificent carved detail of the parlor's horsehair-upholstered sofa shows an eagle back and stylized dolphin legs. Created *c*. 1810, it is one of only about 10 custom-made sofas with similar detail attributed to the famous cabinetmaker Duncan Phyfe. As one of the itemized objects in Clemson's will, the sofa is part of Fort Hill's core collection. T.G. Clemson received it from his sister Louisa Clemson Washington, wife of the first President's grandnephew.

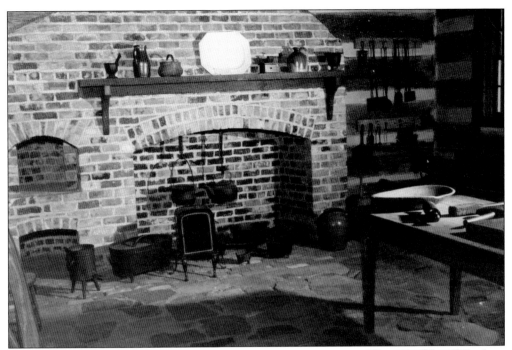

As is the case with most homes built in the 18th and 19th centuries, the Fort Hill kitchen is separated from the main house by a breezeway to reduce the fire danger. Food was carried some distance to the dining room. The kitchen contains a large, open fireplace with suspended kettles, ovens, utensils, and bowls used at the time for food preparation and serving.

The burial ground on Cemetery Hill overlooking Death Valley has served for decades as a place of repose, offering peace and reflection to students, faculty, and visitors alike. At Woodland Cemetery, a visitor will find many markers with cherished names such as Riggs, Sikes, and Fike. The pictured memorial honors members of the Calhoun family. John C. Calhoun is buried at St. Philip's churchyard in Charleston, his wife Floride Colhoun Calhoun at St. Paul's in Pendleton.

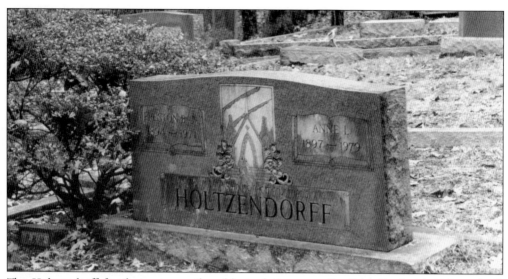

The Holtzendorff family is among the oldest of our state. Dr. John Frederick Holtzendorff, an aristocratic Prussian physician and soldier, is mentioned in 1733 in a letter of the Duke of Newcastle to Governor Johnston. He served first as captain and physician in the new South Carolina Township of Purrysburg, later as surgeon of St. Philip's Hospital in Charleston. At his death in 1754, he left five sons and three daughters. Clemson's "Mr. Holtzy," Preston Brooks Holtzendorff, Jr., served in the United States Army Air Corps in World War I and then was general secretary of the Clemson YMCA for the next 40 years.

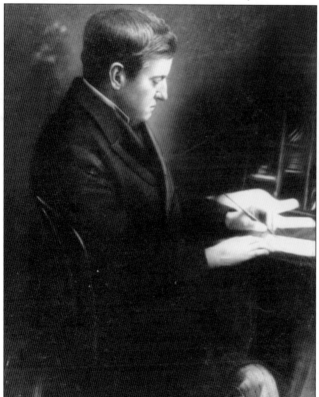

After helping to establish Clemson Agricultural College, Benjamin Tillman (1847–1918) became governor of South Carolina from 1890 to 1894, winning a reputation as an early Southern demagogue with his fiery tongue. His governing policies, however, were mainstream conservative. He worked hard to curb lynching in the state, but advocated segregation. In 1894, he was elected to the United States Senate where he was an activist for Southern farmers. He earned his nickname, "Pitchfork Ben," when he attacked President Grover Cleveland in a rousing speech for his neglect of the economic depression, and threatened to go to the White House to "poke old Grover with a pitchfork" to prod him into action.

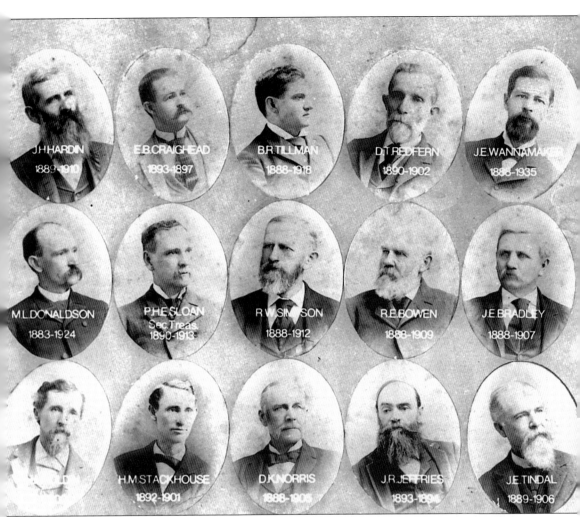

The collage shows the likenesses of some of Clemson's early trustees and administrators. From left to right are (top row) J.H. Hardin, trustee from 1889 to 1910; E.B. Craighead, president from 1893 to 1897; B.R. Tillman, life trustee (1888–1918); D.T. Redfern, trustee from 1890 to 1902; and J.E. Wannamaker, life trustee (1888–1935) and board president from 1929 to 1935; (middle row) M.L. Donaldson, life trustee (1883–1924); P.H.E. Sloan, secretary-treasurer from 1890 to 1901; R.W. Simpson, life trustee (1888–1912); R.E. Bowen, life trustee (1888–1909); and J.E. Bradley, life trustee (1888–1907); (bottom row) W.H. Mauldin, trustee from 1893 to 1900; H.M. Stackhouse, trustee from 1892 to 1901; D.K. Norris, life trustee (1888–1905); J.R. Jeffries, trustee from 1893 to 1894; and J.E. Tindal, trustee from 1889 to 1906.

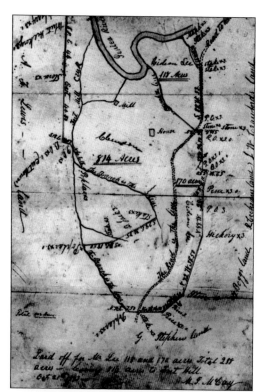

The map from Thomas Green Clemson's will shows Fort Hill and its surroundings, with the Seneca River as the uppermost boundary.

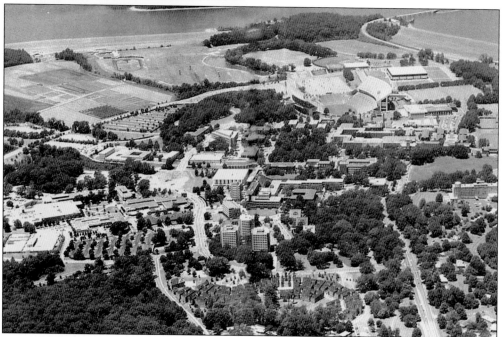

This modern view depicts the development that has taken place in the past century. The area to the left of Cooper Library is awaiting construction of the Strom Thurmond Institute and the Brooks Performing Arts Center beyond. The Calhoun mansion is hidden by the grove of trees to the upper right of the library.

Two

THE EARLY YEARS

Between 1890 and 1910 Clemson Agricultural College had five presidents: Henry Aubrey Strode (1890–1893), Edwin Boone Craighead (1893–1897), Henry Simms Hartzog (1897–1902), Mark Bernard Hardin (1897, 1899, and 1902), and Patrick Hues Mell (1902–1910).

When Strode reported for duty in August 1890, the trustees had already created an executive committee charged with the construction of a campus and a curriculum committee. With monies from the fertilizer tax, the Trustee House had been constructed, and the following additional buildings were erected with the same funding source: Hardin Hall (1890), Kinard Annex (1893), Tillman Hall (rebuilt in 1894), Godfrey Hall (1898), Sikes Hall (1904), and Holtzendorff Hall (1914). In 1890, agricultural chemical regulation was initiated at Clemson through fertilizer inspection and an analysis program. In the following year the Fertilizer Department, the laboratory for fertilizer analysis, and mechanical equipment was moved from Columbia to Clemson. The transferral of existing state programs from Columbia, Spartanburg, and Darlington and the acquisition of buildings and farms for the experiment station assured continuance of these services and made Clemson eligible for the federal and state funds that supported them. By the end of 1890 over 600 young men had already applied for admission.

In July of 1891, the cornerstone had been laid to the main classroom building and construction had begun with convict labor on dorm, kitchen, infirmary, and boiler room facilities. By fall, the chemistry lab, Mechanical Hall, experiment station, and the access road to Pendleton were completed or under construction. In 1892, stables, silos, and a canning factory were added and 1,400 fruit trees planted.

The year 1891 also saw the hiring of the first instructors. A.V. Zane, the first professor of applied mechanics, was assigned to Clemson by the United States Navy; the first commandant, Lt. E.A. Garlington, was instructor of civil engineering. Both had been replaced by 1893. Of the first professors hired in the summer of 1891, many were South Carolinians and were considered "chairs" of emerging departments. Charles M. Furman (English) and William S. Morrison (history) each received $2,000 in salary. M.B. Hardin (professor of chemistry and director of the fertilizer lab) received $2,500, and J.S. Newman (professor of agriculture and vice-director of the experiment station) had a salary of $3,000. President Strode was professor of mathematics, earned $3,500, and also functioned as overseer of construction.

Incoming students in 1893, some as young as 15, had a common curriculum in the first year consisting of mathematics, English, history, botany, animal physiology, physics, and agriculture. In addition, they were required to do practical work and had instruction in drawing and military drills. After the first year, students could choose between an agricultural and a mechanical degree program. In the first year, 165 enrolled in the mechanical, 87 in the agricultural curriculum, and 202 entered preparatory courses for those without access to high schools. Students "of means" were required to pay a tuition of $40 and $104 annually for room and board. "Poor boys" paid only for room and board. Two hours of practical work in field and shop was required daily of all students. In his report to the board in 1894, President Craighead wrote the following:

> Labor of the hand as well as of the head, labor in the shops as well as in the fields, is expected and demanded of all who enter here.

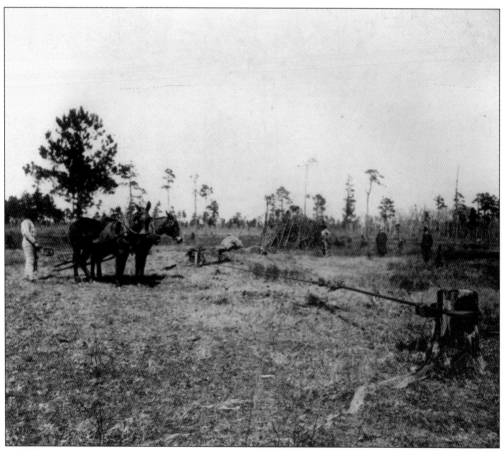

The earliest buildings were constructed by a convict labor force that lived on site in a camp. In this photo, a number of dignitaries at right watch what may be the original ground breaking on Fort Hill.

The Trustee House was the first building completed with funds from the fertilizer tax (1889). In January 1890, the trustees met and formed an executive committee that began advertising for bids, receiving architects' proposals, choosing building sites, and arranging for timber cutting.

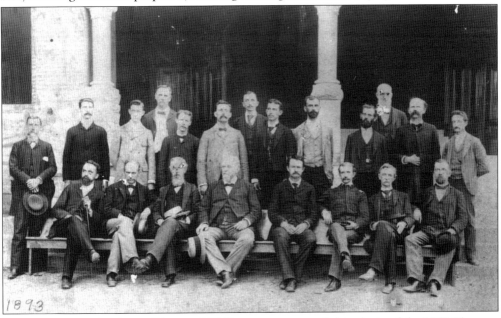

Mrs. W.W. Klugh, daughter of Trustee R.W. Simpson, presented this photo of the 1893 Clemson faculty. Among them—from left to right on the front row—are C.W. Welch (physics), H.A. Strode (mathematics), M.B. Hardin (chemistry), J.S. Newman (agriculture), President E.B. Craighead, Lt. T.Q. Donaldson Jr. (commandant of cadets), Charles M. Furman (English), and William S. Morrison (history).

Some of the incoming students already had some military training. Among them were Rudolph E. Lee and Carter Newman, who, according to Tillman, were instrumental in helping Lt. T.Q. Donaldson Jr. in "organizing raw recruits into squads." Pictured above are the D-Company "Rats."

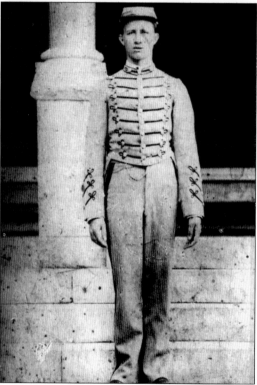

The first board-approved contracts for uniforms specified the following: "Fatigue suit, best grade Salem jeans, $5.00. Jeans cap, 75 cents. Dress suit, 24 oz. Charlottesville goods, West Point cut and trim, $16.75. Cap, $1.65." Among the entering students in 1893 was Cadet L.E. Gable. He is reputed to have been the first to enter the barracks on opening day, July 7, 1893.

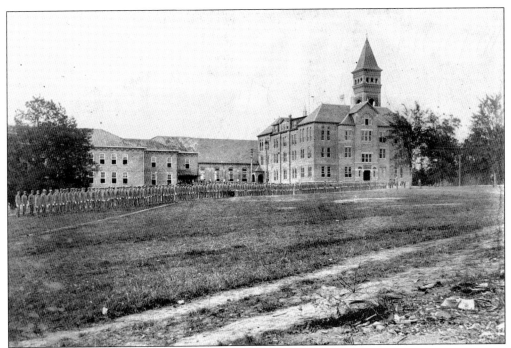

The Cadet Corps was mandatory from 1893 until 1955. Initially, military drills were a curricular requirement for all students, supplemented in the junior and senior years with instruction in military tactics and military science. This photo shows the first dress parade in front of the barracks and Tillman Hall.

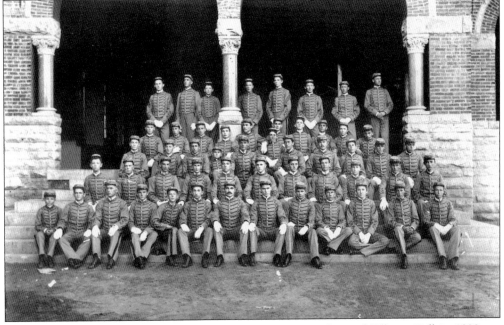

Social clubs and societies were established early. Shown in front of Tillman Hall in 1893 are members of the Calhoun Literary Society, which later sponsored the *Chronicle*, the student literary magazine founded in 1898. The Glee Club was organized by Walter Riggs in 1896.

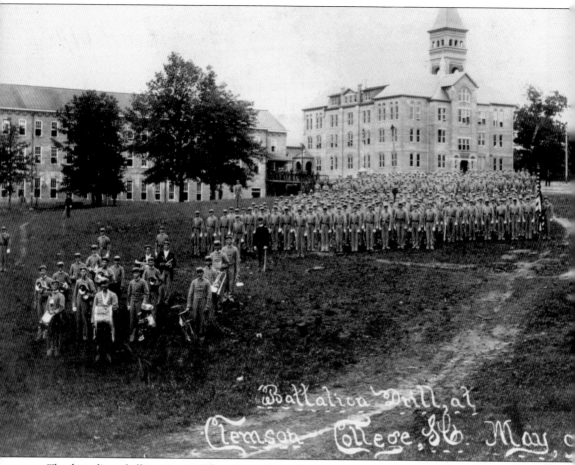

The battalion drill in May 1894 is the earliest photo in existence of the entire student body. Shown are the original No. 1 Barracks on the left and Tillman Hall on the right, shortly before it was destroyed by a major conflagration.

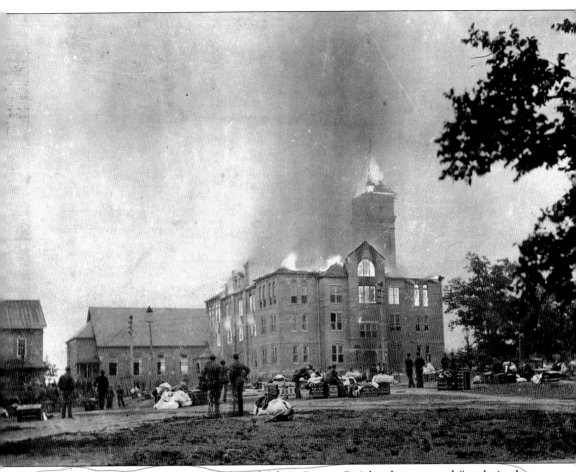

On June 21, 1893, the trustees had elected Edwin Boone Craighead to succeed Strode in the presidency. The 33-year old professor of Greek was the only Clemson president ever to be trained in the humanities. Not yet a year in office, Craighead witnessed the main building on campus destroyed by fire. During the night of May 22, 1894, the blaze started on the third floor, where the laboratory, museum, and fitting (preparatory) school were located, and it rapidly spread throughout the building. The school's entire library was quickly consumed by the fire, including books that belonged to Calhoun and Clemson. Classrooms and offices were also gutted, but reconstruction began immediately.

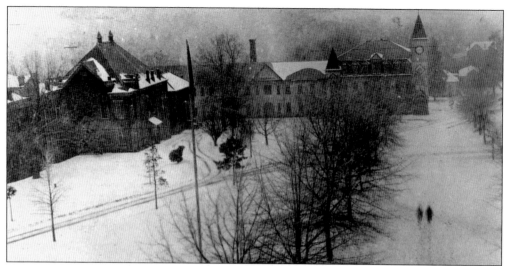

Construction was an ongoing venture in the first decade of Clemson College. A rare picture of the campus covered in snow shows Hardin and Mechanical Halls, two buildings that were among the first to have building plans approved by the board, and also suffered fire damage later. Both were completed by the time Tillman Hall burned. In the mechanical building, seen here at the right and in the photo below, engineering students were trained both in shop work and in theoretical knowledge.

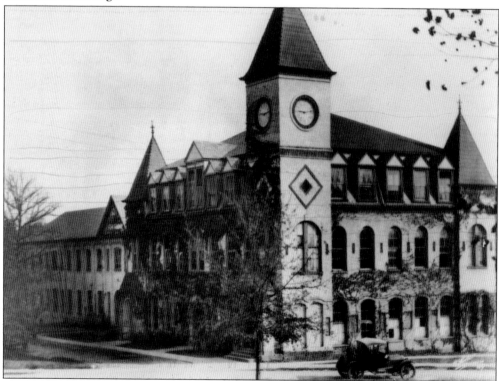

Beautiful Mechanical Hall was a two-story brick building, about 100 by 40 feet, with a single-story 100-foot extension that contained an engine room and had a smokestack. Gas and water distribution systems were housed in a two-story brick laboratory with a half-basement.

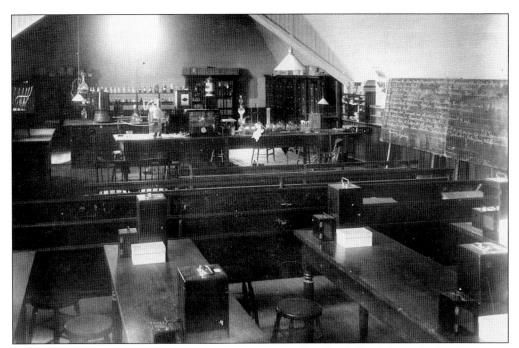

Hardin Hall, originally the chemistry building, was completed with funds from the fertilizer tax in 1890 as the first classroom structure on campus. This photograph offers a view into the botanical lab of 1897.

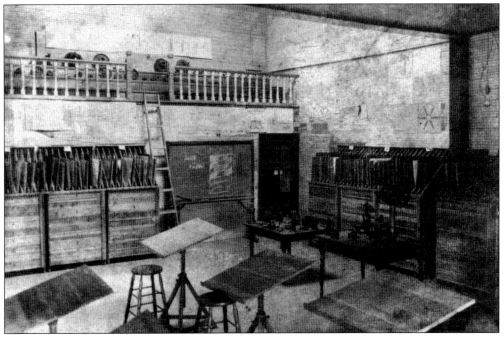

In 1895, the college was reorganized into agricultural, mechanical, chemistry, science, military, and literary departments, but degrees were still only conferred in agricultural and mechanical studies. Of the first graduating class in 1896, 21 received degrees in mechanical-electrical engineering and 16 in agriculture. The photo shows the mechanical engineering drawing room.

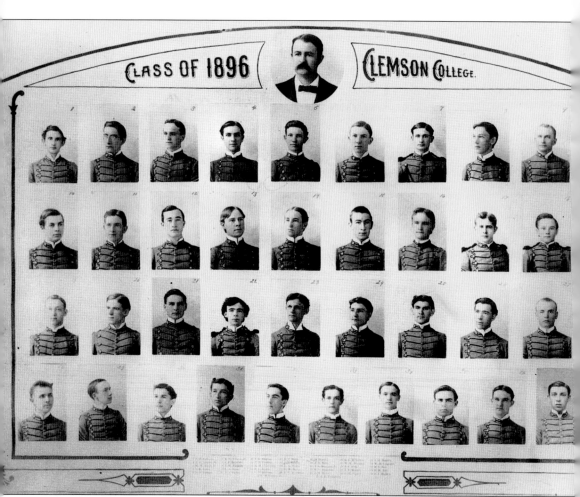

A memorable year was 1896. The first graduating class, shown with President Craighead, numbered 16 agriculture and 21 mechanical-electrical engineering graduates. Agriculture degrees were received by J.M. Blaine, G.P. Boulware, J.F. Breazeale, J.F. Folk, C.M. Furman Jr., P.H. Gooding, R.G. Hamilton, J.H. Moore, T.S. Moorman, B.F. Robertson, B.F. Sloan, R.I. Spencer, B.R. Tillman, F.G. Tompkins, B.R. Turnipseed Jr., and L.A. Wertz. Graduating engineers were B.M. Aull, J.T. Bowen, J.T. Bradley, F.L. Bryant, P.N. Calhoun, W.H. Carpenter, A.M. Chreitzberg, T.W. Cothran, D. Dowling, E.P. Earle, G.W. Hart, J.E. Hunter, W.W. Klugh, P.G. Langley, R.E. Lee, I.M. Mauldin, O.M. Peques, J.G. Simpson, A.J. Tindal, T.H. Tuten, and W.W. Wardlaw.

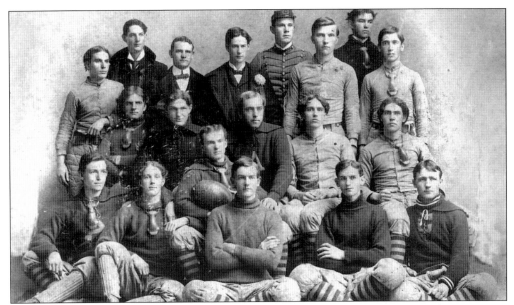

Clemson's first football team of 1896 with trainer Walter Riggs is shown on the cover. In 1897 the team won the state championship. Coach Riggs, himself one of the best tight ends in Auburn's football history, is in the middle of the back row. W.T. Brock and the players of the first football team adopted the Bengal Tiger.

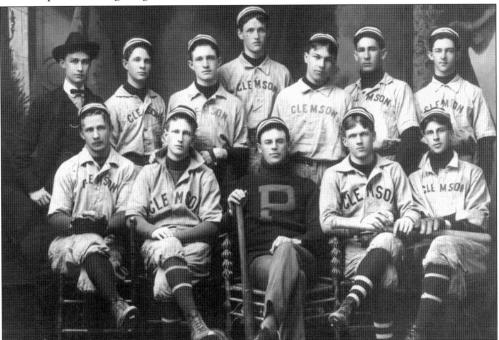

Walter Riggs came to Clemson from Auburn in February 1896 as an assistant in mechanical and electrical engineering. Among the campus and state organizations he established was a baseball team. Riggs brought to Clemson John Heisman, who, although better known for football, coached Clemson baseball from 1901 to 1904. Shown in the second row on the left in this 1903 photo, Riggs became Clemson's fifth president in 1910.

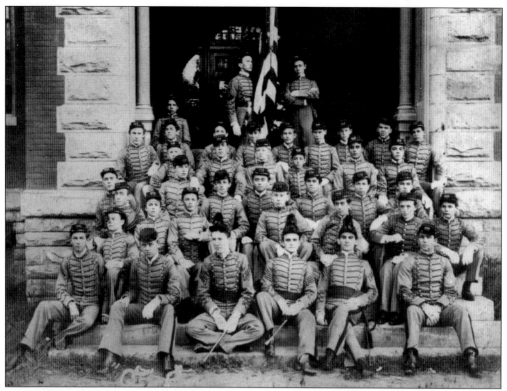

"C" company won the flag for being best drill company in 1896. The company is photographed in front of Tillman Hall with Capt. W.W. Klugh.

From the beginning, the college programs stressed educating the public through the extension and outreach services. Forest management and timber operations stressed pest management, improved productivity through basic and applied science, and the utilization and protection of natural resources. This class achieved 7.5 cords of wood per acre.

Walter Riggs was also responsible for bringing Auburn's popular football coach John Heisman to Clemson. With a pledge dated December 8, 1899, the undersigned promised to pay Heisman's salary for 1900, "provided that this agreement shall entitle us to membership in the Foot Ball Association, with full privileges to vote and to participate in the direction of its affairs." A total of $415.11 established the association. With $65.11 Riggs contributed the largest single amount.

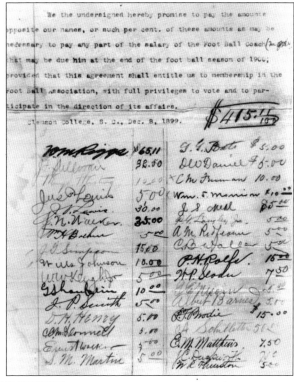

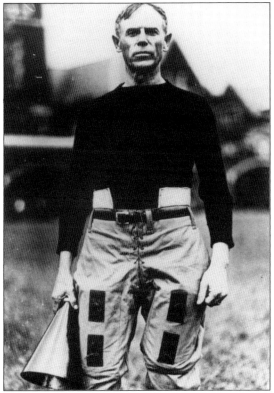

John Heisman coached at Clemson for some time (first years)

Football legend John Heisman was born Johann Wilhelm Heismann in Cleveland, Ohio in 1869. He changed his name to John William Heisman when he enrolled at Brown University where he played tackle, then transferred to Pennsylvania. Heisman began his coaching career in 1892 at Oberlin College, then went to Akron and Auburn. At Clemson Heisman coached from 1900 to 1903 with a perfect season of 6-0 in 1900 and a four-season record of 19-3-2. Heisman brought big-time football to Clemson, earning $1,800 a year. The name of the DAC Award was changed to Heisman Trophy following Heisman's death in October 1936.

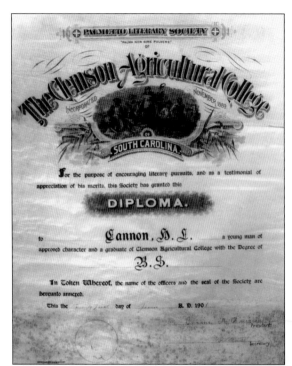

Under President Craighead, three literary societies began to thrive. The *Calhoun*, the *Palmetto*, and the *Columbian* attracted members for debate, oratory, and declamation. President and faculty contributed $250 for the purchase of periodicals, and $1,000 had been set aside by the trustees for the acquisition of books for the library and its reading room. The Palmetto Society, established "for the purpose of encouraging literary pursuits," awarded H.L. Cannon this diploma in 1901.

Photos from around the turn of the century illustrate the changing interests of the chief executives. These students, proudly showing off their books at the old chemistry building, seem to express President Craighead's priorities, which urged the trustees to "continue to make liberal appropriation for the purchase of new books so much needed by our students," because "without a good library, no college is complete."

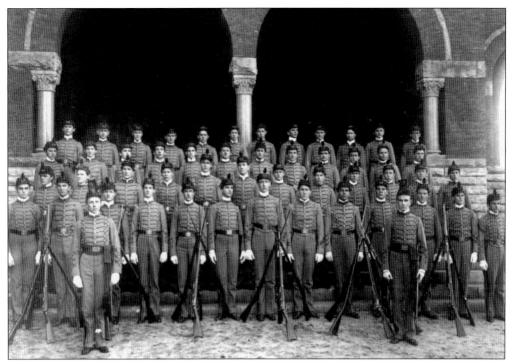

President Henry Hartzog was a graduate of the South Carolina Military Academy (the Citadel) and is said to have carried brass knuckles as a 10-year-old boy in support of Gen. Wade Hampton's gubernatorial bid. Son of a prosperous South Carolina planter family of Swiss descent, Hartzog also held a divinity degree and had served as a newspaper editor in Bamberg. A large student walkout in 1902 over the application of rigid military discipline evolved into hostilities between students and faculty, eventually included the president and trustees, and led to Hartzog's resignation.

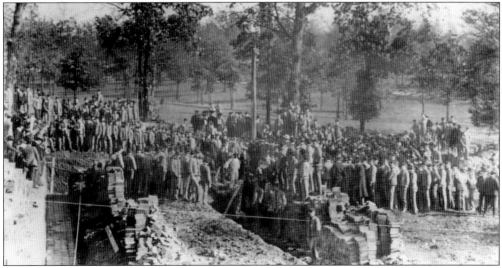

It was also Hartzog who created the textile department that became a turning point in Clemson's history. Cadets are shown assembled in 1898 at the future site of the textile building, later called Godfrey Hall, in this early construction photo.

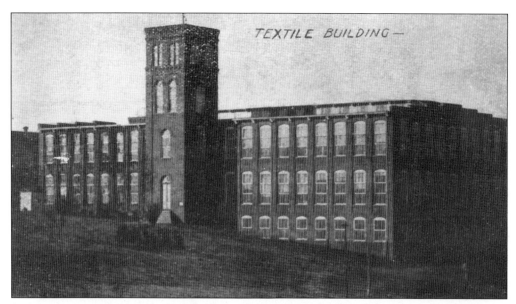

An increase in students and a broader base of support were achieved by opening Clemson to a cooperative relationship with dynamic enterprises in all facets of the textile industry. Hartzog's foresight permitted Clemson to assist in South Carolina's industrialization, and today's research in space-age fabrics continues to revitalize the state's economy.

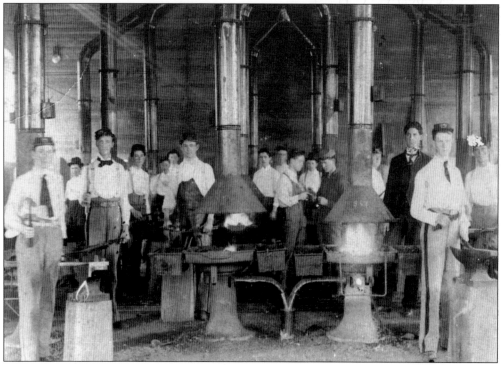

Hartzog's educational objective was fourfold: to produce a skilled mechanic, an expert mathematician and scientist, a fine businessman, and a person of culture. The engineering curriculum in 1901 included forge and foundry work, as well as agriculture studies and four years of English and history. The photo shows a forge class around 1900.

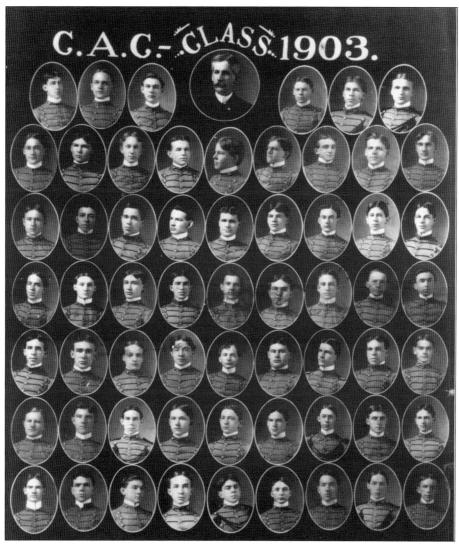

Pres. Patrick Hues Mell came to Clemson from Auburn in August 1902 as a nationally recognized scientist and scholar. During his tenure at Clemson, the longest of any president up to that time, Mell inherited the problems of his predecessors and encountered some of his own. Charges of nepotism at the college were leveled in 1906 by gubernatorial candidate John J. McMahan. He called Clemson "a closed corporation, largely officered by the kinsmen and other favorites of these life trustees," and charged that "nepotism, the bane of efficiency and fairness, honeycombs the institution." In 1909, a legislative committee, with Mell's cooperation, found that 10 Clemson officers and professors were related to trustees. This class picture of 1903 shows Mell with graduates, pictured from left to right, starting at the top, (first row) Barnwell, Perrin, Humbert, Legerton, Chisolm, and Harrall; (second row) Morrison, Marvin, Holland, Glenn, Tillman, Sahlman, Wightman, Garrison, and Larsen; (third row) Pollitzer, Earle, Finger, Epps, Ellis, Livingston, Cain, Bradford, and Prioleau; (fourth row) Cullum, Gandy, Wyse, Gardner, Freeman, Hagood, Sadler, Newell, and McSwain; (fifth row) Norris, Harvey, Fox, Whitney, McCrary, Green, Young, Kaigler, and Jeffries; (sixth row) Robertson, Lawrence, Cunningham, Cummins, Beaty, Wylie, Williams, Quattlebaum, and Lewis; (seventh row) Rhodes, Haynesworth, DeSaussure, Pegues, Boineau, Black, Alford, Cunningham, and Milling.

Clemson's student newspaper featured the Clemson vs. Georgia Tech game on the front page of volume 1, number 1 on January 21, 1907.

The Tiger Train involved the Clemson Carolina rivalry (first years)

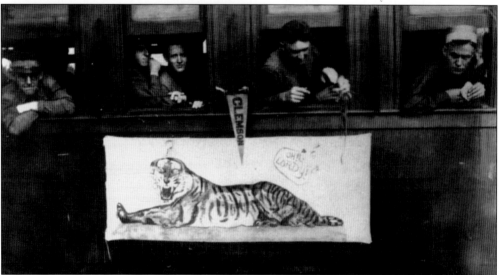

The "Tiger Train" to Columbia for the football game became a time-honored tradition. President Mell had barely assumed office when the "big game" of 1902 embroiled him in a media controversy over a lack of discipline among Clemson students. After the game, which Carolina won 12-6, a melee arose over a Gamecock banner gleefully depicting Clemson's defeat, and several Carolina students were roughed up by Clemson cadets. Coming so soon after the student walkout, the perceived lack of discipline caused *The State* newspaper to question whether the "very liberal support" of Clemson by the state was justified. From the beginning until 1960, the Tiger-Gamecock classic was played at or near the Columbia State Fair grounds. The governor sat in a distinctive box for the first half on the Clemson side, for the second half on the Carolina side.

Football was big even then

"Riddle me this," asks this picture worth a thousand words. *TAPS* of 1909 offers clues with tongue-in-cheek contributions by "Sherlock Holmes" on "the mystery," the satirical account of an off-campus pursuit on foot titled "race question," a "Professor's notebook" explaining the triple meaning of "rat" (cleaning woman, freshman, betrayal), and other tantalizing bits of clues. Reference is made to the 1908 "Pendleton Guards" and their march to Pendleton, which resulted in the dismissal of 306 sub-freshmen, freshmen, sophomores, and juniors. This photo of the Class of 1909 and sophomores shows survivors. What had started as a prank was punished as desertion and a challenge to the authority of Commandant J.C. Minus.

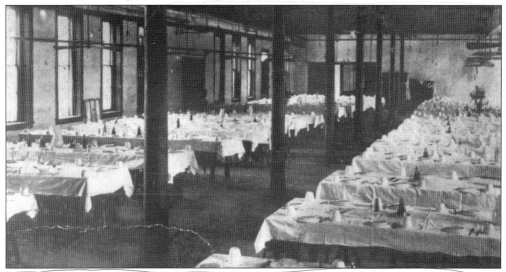

This festive dinner setting shows the mess hall in 1910. Holiday fare received special care, and food was always a major concern of student life then as now. Long-term mess officer August "Shorty" Schilletter introduced cream puffs as a special treat at a Junior-Senior Banquet, and during president Craighead's tenure a mere $7 paid for a month's board. Unfortunately, President Riggs discovered in 1912 that Schilletter had taken the term "mess hall" a little too literally in his accounting practices and was deplorably "short" with the funds entrusted to him.

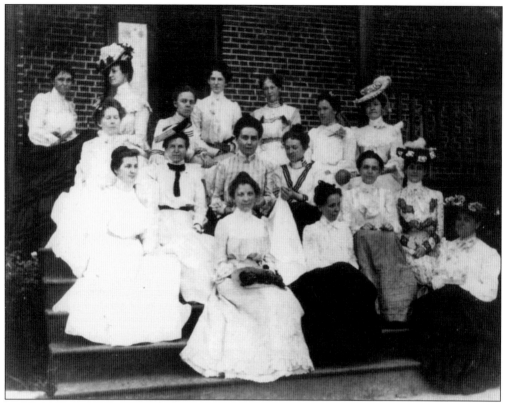

Women were always a part of the Clemson campus in offices, housekeeping, and at social functions. For overnight stays after formal dances, the ladies stayed at the home of friends or at the Clemson Hotel, which also rented rooms and apartments to faculty. This happy photo shows the wives of Clemson College's first graduating class at a reunion in 1910.

This postcard offers a view of Clemson's former horticulture grounds. With its emphasis on the cultivation of fruits and vegetables, it was a more practical forerunner to the magnificent ornamentals found today in Clemson's South Carolina Botanical Gardens.

Three

EDUCATING SOUTH CAROLINA

The next 30 years defined and shaped the identity of Clemson College under the two long-term Presidents Walter Merritt Riggs (1910–1924) and Enoch Walter Sikes (1925–1940). After President Mell's resignation, Walter Riggs became chief executive. The reorganized and renamed engineering department now provided instruction in mechanical, electrical, and civil engineering, shop work, physics, and drawing. Prof. Rudolph E. Lee, who headed the drawing division, also served as the college architect and supervisor of campus construction. Holtzendorff Hall was constructed in 1914 with funds from the fertilizer tax.

The agriculture department boosted its enrollment with scholarships and now had as many students as engineering. With the creation of the South Carolina Quarantine Act and the South Carolina Crop Pest Commission (SCCPC) in 1912, Clemson became the plant quarantine authority for the state. Three years later the work of public service activities, including extension and experiment stations, was funded with fertilizer tax monies. Boll weevil and citrus canker required crisis intervention and enforcement actions by the SCCPC in 1917 and a citrus quarantine was implemented.

In 1913, the fitting school was abolished and an entrance examination was required for new students without a high school certificate. World War I had a multifaceted impact on Clemson. Enrollment dropped drastically. The Reserve Officer Training Corps (ROTC) had been established by the National Defense Act of 1916 and Clemson had a unit as early as 1917. A year later the Student Army Training Corps (SATC) was formed. The army paid SATC members' board and tuition, and vocational subjects such as carpentry and blacksmithing were also taught. Despite well-equipped facilities and a steady demand for its graduates, the Textile School continued to have enrollment problems. Faculty decided to provide extension work in the form of lectures at industrial sites such as Pacolet and Newry, and a popular new course in cotton grading was offered during the summer. The state legislature also assigned Clemson the task of producing state flags for sale at cost.

Wartime shortages produced changes in the faculty, notably the hiring of the first women faculty at Clemson. In the fall of 1918, the nationwide outbreak of influenza that killed more than 500,000 Americans reached Clemson. About 400 students were sent home from October 8 to November 9 as a precautionary measure. At Clemson, only one student and one professor, W.W. Routten, head of the wood shop division, lost their lives. The infant daughter of drawing

professor W.W. Klugh also succumbed. In February 1919, President Riggs accepted six months of service as one of the directors for the army's educational commission in France, leaving Samuel Broadus Earle in charge. Riggs left rigorous instructions for the acting president, which Earle accepted because "I felt it might be my duty." Earle remained head of engineering during that time and hired Rosamond Wolcott as temporary replacement for her brother in architecture.

On March 10, 1920 a massive walkout occurred by what Riggs called "the Bolshevik Class of 1920." More than 400 of the 779 cadets left campus to return home, protesting what was termed a "prison camp"-style military discipline, "unscrupulous," or "high-handed" treatment, and bad food. The rebellion resulted in the creation of a Department of Student Affairs, with D.H. Henry, professor of chemistry, as its director. On January 22, 1924, President Riggs died suddenly on a business trip to Washington, D.C., and Earle again became acting president. The last, and perhaps the most disruptive, student walkout occurred in October 1924. About 500 students left campus when Earle rejected a petition by seniors, demanding more and better food, the dismissal of the mess officer J.D. Harcombe, and the reinstatement of R.F. "Butch" Holahan. Holahan, who was senior class president, captain of the football team, and very popular among students, had been accused by Commandant O.R. Cole of having "liquor on his breath." The board's punishment was swift—23 students were dismissed, 112 suspended, 65 honorably discharged, and 36 unwilling to return withdrew.

> Success only feeds the appetite of aggression.
> —Lyndon B. Johnson

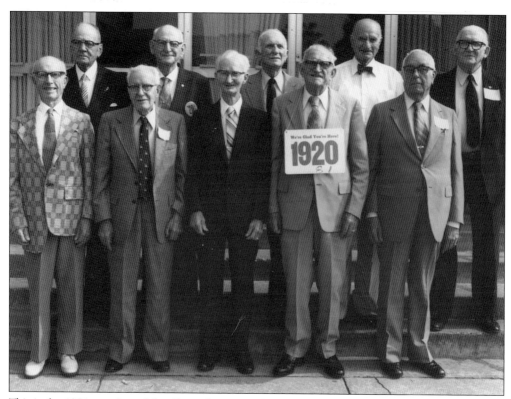

This is the 1981 reunion of the Class of 1920 at Clemson.

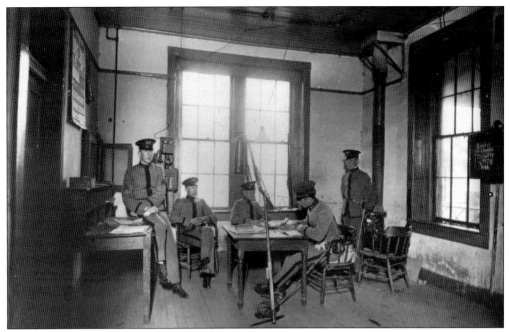

Cadets are shown in the guardroom of Barracks No. 1. College rules did not permit possession of civilian clothes. Cadets rose at 6 a.m. Study hours were set in the evening, students were not permitted to speak after the playing of taps, and it was forbidden to go to bed before 10:30 p.m.

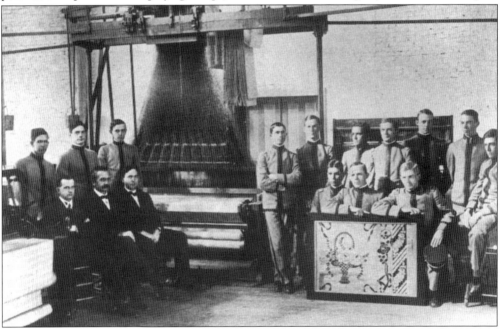

In March 1898, the college had established a course in textile engineering, making Clemson the first Southern school to train textile specialists. Equipment donated by textile companies permitted spinning, knitting, and weaving operations located in Godfrey Hall. The textile-engineering curriculum was initially similar to that of mechanical engineering, with textile work substituted for mechanical classes and labs. This photo dates to c. 1911.

Since 1895, the agricultural department taught horticulture, dairy farming, botany, and veterinary science, and it included the experiment station and farms with farm animals. This photo from about 1911 shows a class in veterinary science. After World War I, the agricultural department started a vocational training program for disabled veterans. It was discontinued in 1924.

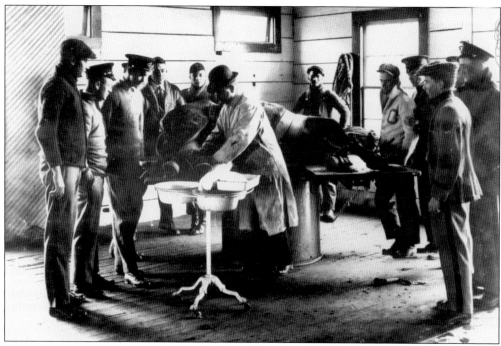

Cadets watch a surgical procedure in the veterinary science laboratory around 1915.

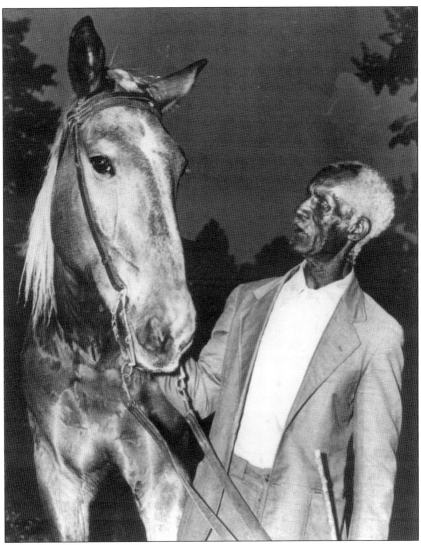

Numerous stories are told about Bill Greenlee, whose place at Clemson was assured since his early boyhood buggy rides with the college's founder—one day he might study at the college he would build, T.G. Clemson had declared. As an adolescent, Bill worked as water carrier for the construction crews and greased the mold for making the bricks for Hardin Hall. He married Annie Reid and owned a chestnut-colored riding horse he named "Dan." Working on the Clemson farms, Bill one day saved the college's prized cattle from the Seneca River's swiftly rising currents, leading them to safety with his horse. For his heroic deed, Clemson College made him the official trash collector—a "guaranteed connection," Bill quipped. With good-natured humor, Bill called himself Head of the Sanitary Department and no longer did plowing chores. "Hoeing and chopping are not in my repertoire," he said. During the Depression, Bill declared, "I feed my horse first, then Annie and I get along on what's left." In May 1958, he and Annie celebrated their 60th wedding anniversary. Campus children went for a ride on Bill's wagon on their birthdays and all of Clemson commemorated Bill's 100th birthday in 1970. Bill Greenlee never studied at Clemson, but he witnessed Harvey Gantt receive his degree in the 1960s and inspected Abe W. Davidson's statue of Thomas Green Clemson in front of Tillman Hall—"real natural," he said of the man he knew.

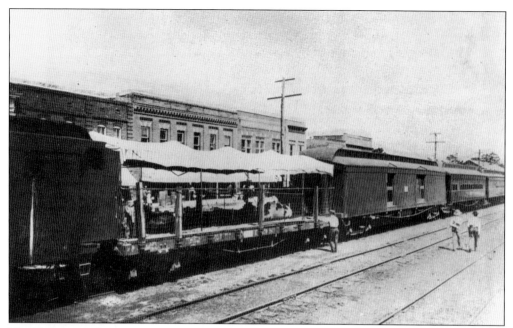

The Clemson College Extension Train traveled the state to bring new agricultural methods and techniques to the farmers, many of whom did not have electricity until the 1930s. At every stop of the train, "institutes" were held for the farmers of the community. This photo of 1911 shows the bovine exhibit items.

Some faculty members of the agricultural department "lived" on the College Extension Train as it made its way around the state. Here one of the professors takes a quick nap between lectures.

A 1914 advertisement for Clemson Agricultural College states an enrollment of 834, 12 degree programs in 26 departments, and over 90 teachers and officers. One-hundred sixty-eight four-year scholarships in agricultural and textile courses offered $100 and free tuition. The regular cost of the same was $133.40 per session, covering uniforms, room and board, heat, light, water, laundry, and fees, except $40 tuition for those able to pay. The ad also notes "a flourishing Sunday School and Y.M.C.A." and inter-collegiate baseball, football, track, tennis, basketball, three literary societies, and four student publications. "The Legislature of South Carolina makes no appropriation for the support of Clemson College," the ad emphasizes.

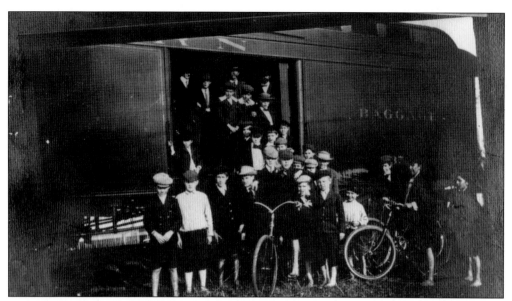

The Clemson Extension Train created great interest when it came to town. Barefoot boys in their Sunday best met the train and its faculty in *c.* 1905.

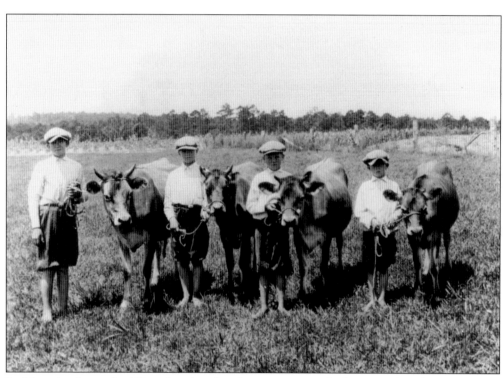

In this early photo of a 4-H project, barefoot boys are seen with their prized cattle. In 1908, the first boys' corn club in South Carolina was organized. In 1909, Jerry Moore of Florence County set a world record when he produced 228.75 bushels of corn on his acre of land. Clemson gave him a scholarship.

Chemistry was taught in labs such as this by 1911. Beginning in 1917, a degree in chemical engineering was offered, and in 1938 chemical engineering became chemistry-engineering. A major purpose was to train industrial chemists who were needed in the state's pulp and paper industry.

Initially, T.G. Clemson's concept of learning was interpreted chiefly in practical terms. Instruction in theory and basic science were aimed at usefulness. Students were taught to draw, cast, and assemble an internal combustion engine, but not to design or modify it. Similarly, hydrological concepts were taught in terms of application needs. Today's annual concrete-boat-building contest would have seemed strange to these students in 1911.

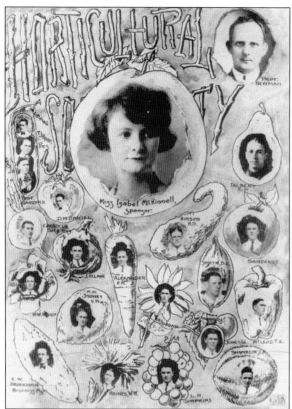

An early roster of the Horticultural Society shows Charles Carter Newman, who came to Clemson in 1896 and was horticulture professor from 1899 to 1946, and Professor Gardner, envied owner of an E.M.F. automobile. Ladies were chosen as sponsors (here Isabel McKinnell). Professor Newman developed a spineless variety of okra at Clemson and was a pioneer in the use of trellises for muscadine grapes. An endowed chair of natural resources engineering was established in his name in 1973 by his son, J. Wilson Newman. The roster also shows W.W. Klugh (1896, later on the engineering drawing faculty), E.R. Alexander, E.W. Brockman, L.G. Causey, D.M. Daniel, W.W. Haines, T.J. Hart, H.S. Hinson, G.L. Jones, E.H. Jordan, C.B. King, J.M. Law, T.E. McLeod, E. Sanders, J.R. Shanklin, L.H. Simpkins, D.E. Smith, P.D. Stoney, E.M. Talbert, and J.H. Thomas.

Bee culture was also taught in the College of Agriculture. An apiarist's protective gear and honeycombs are admired here by students.

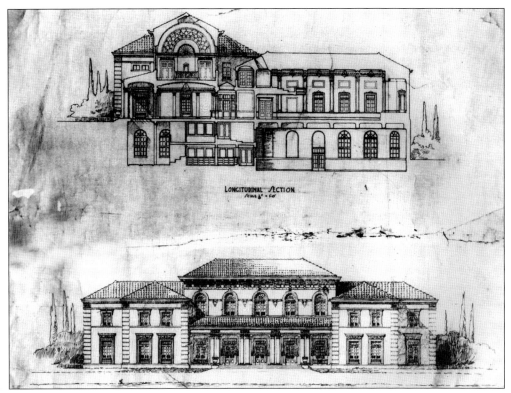

The Holtzendorff YMCA (front elevation) was built in 1914. Rudolph E. Lee, head of the engineering drawing division, was the campus architect. S.B. Earle designed lighting, heating, and plumbing at the YMCA. It helped to avoid "temptations to dissipate or spend money foolishly," as a Clemson ad claimed.

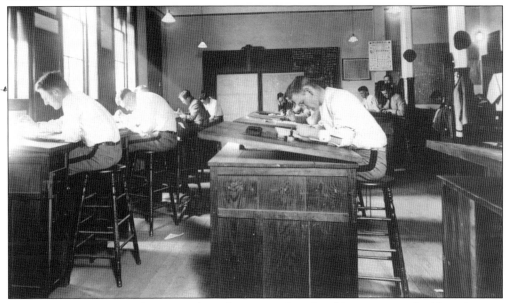

An engineering drawing class around 1916 is pictured in the old engineering building that was destroyed by fire in 1924.

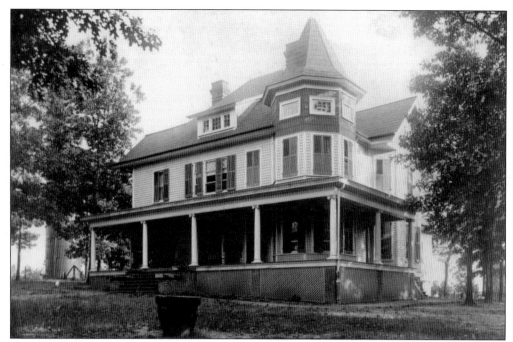

Mary Katherine Littlejohn's humorous description of the old president's home, c. 1930, bears repeating. "A wide hallway from front to back kept the house cool in summer and created a wind-chill factor in winter that resembled a quick trip to Alaska. . . . Each room of the president's home had a fireplace, a ten-foot ceiling with one naked light bulb attached to a long cord swinging from the middle of the ceiling, and a wide-planked floor with vicious splinters. Closets were scarce or unknown." The house was located on a slight hill, facing the main road.

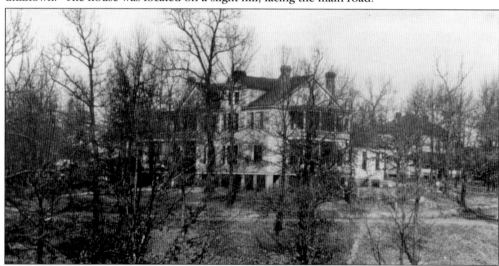

The Clemson Club Hotel stood at the site of the current Clemson House. The two-story, light yellow house was the most comfortable residence for young married couples, staff stenographers, and faculty. An ample table and the best substitute for home also tempted cadets for occasional free food or a helping hand in financial need. After reviewing the hotel's records in 1927, President Sikes found that it was losing $1,500 annually. Monthly room and board was $31. For a short time the hotel was operated as a faculty club.

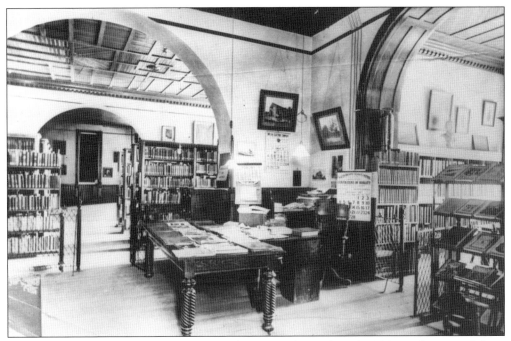

The original library, shown in this 1917 photo, was located until 1925 on the second floor of Tillman Hall. In 1893, an initial appropriation by the trustees of $1,000 for the purchase of agricultural reference books was supplemented by faculty, who offered $5 each to add a reading room. In 1895, another $1,000 appropriation was made to obtain books recommended by faculty. An early librarian was Sue Sloan, daughter of the first secretary-treasurer and later the wife of S.B. Earle. Katherine Bocquet Trescott was in charge of the library in 1905, with assistant Anne Allston Porcher.

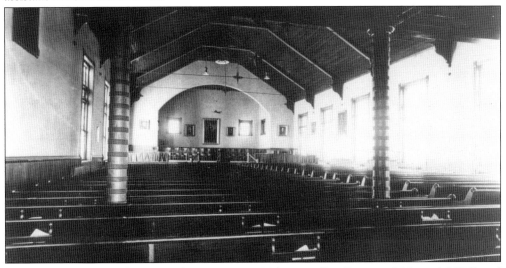

The chapel, shown before its enlargement in 1924, was officially named Memorial Hall and was used as the principal assembly hall for college functions, entertainment, and graduation exercises, as well as for religious services. Initially, cadet companies were marched to weekday morning chapel services for brief devotionals, announcements, and special speakers. Note the full-length portrait of John C. Calhoun facing the heavy pews.

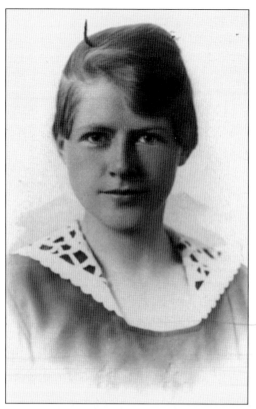

The appointment in 1918 of three women instructors to a previously all-male faculty is attributed to the manpower shortages of World War I. Rosamond Wolcott, who received a degree from Cornell in 1917, replaced her brother for a year teaching architecture while he worked for the government. Acting-president Earle described her as "a very conscientious girl fully qualified to do the work." He felt "not quite sure that it would be wise to continue women teachers, though if we did I am sure Miss Wolcot would be an excellent one for the place."

Mary Hart Evans of Knoxville (shown here), a graduate of the University of Tennessee, was hired as an instructor in botany and later married botany professor W.B. Aull. The third woman appointed in 1918 was Mabel Stehle, graduate of Ohio State, instructor in entomology and French. Two faculty wives, Mrs. George H. Aull (French) and Mrs. W.W. Fitzpatrick (mathematics) were appointed in 1925 and reappointed in 1926. For the next 30 years few women faculty were hired.

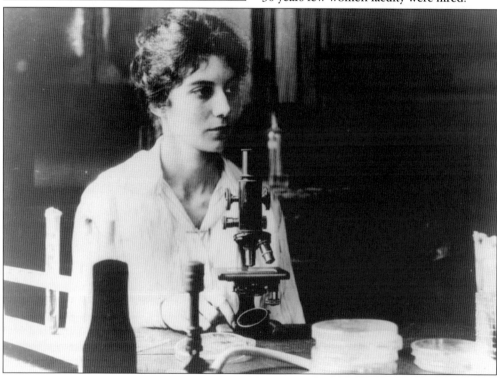

Marguerite Doggett, daughter of textile department director C.S. Doggett, was the librarian in the 1920s, succeeded by Cornelia Graham, the former assistant. In 1918, C.S. Doggett, who was educated in Europe, organized extension classes in South Carolina mill towns to train textile vocational teachers for evening classes. Mrs. Doggett frequently served English "high tea" to students and neighbors.

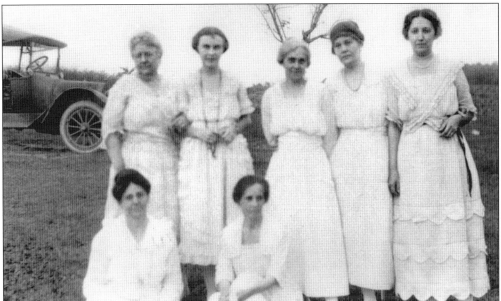

Faculty wives, seen here in the 1920s with J.C. Littlejohn's Buick, were assisting the college in many unseen and largely unappreciated ways. Some, like Mrs. George H. Aull and Mrs. W.W. Fitzpatrick, actually taught courses when the need arose, but others spent hours of unpaid work assisting their husbands and the college with supportive clerical and social tasks. James C. Littlejohn worked for president Riggs for 18 years as registrar and presidential assistant, then as capable business manager under president Sikes.

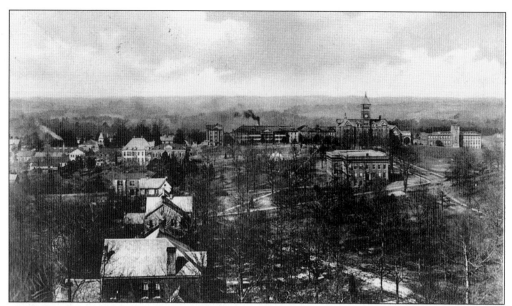

A birds-eye view of the Clemson College campus and its main buildings is provided by this postcard from about 1910. There were no paved roads or walkways. Today's College Avenue was the dirt road connector between Greenville and Atlanta, and horse-drawn traffic was restricted to "ordinary gait." Houses near the college buildings were rented to faculty and staff at reasonable rates. The basic structures were in place, and the college awaited "the Master Executives."

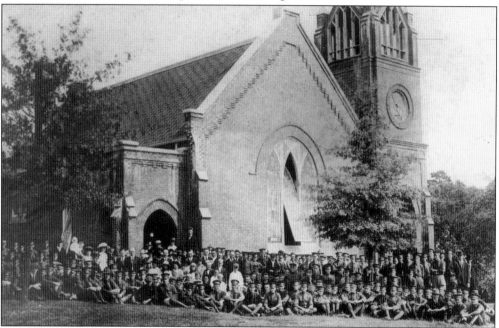

Initially, Sunday services were held in the campus chapel by area ministers who were paid $5 and traveling expenses. Around the early 1900s, Baptist, Episcopalian, Methodist, and Presbyterian denominations organized to erect church buildings near campus. Other denominations followed later. Although Sunday chapel services were then discontinued on campus, church attendance remained compulsory. These cadets are assembled c. 1920 in front of the Episcopal Church.

The faculty poses with President Riggs in front of Tillman Hall around 1920.

The Junior Class officers of 1923 with their sponsor, Miss Weissinger, are shown in this *TAPS* photo. R.F. "Butch" Holahan (right), then the class vice president, was informed by President Earle of his dismissal on October 14, 1924. About 500 students left campus in the largest and last student walkout when Earle rejected a petition by seniors, demanding the reinstatement of Holahan. The popular captain of the football team and senior class president had been accused by Commandant O.R. Cole of having "liquor on his breath." The fallout from the walkout appeared nationally in press accounts. Criticism centered on Clemson's system of military discipline and the lack of a student government.

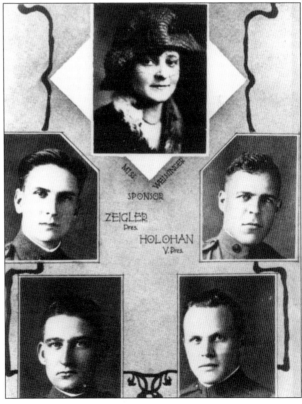

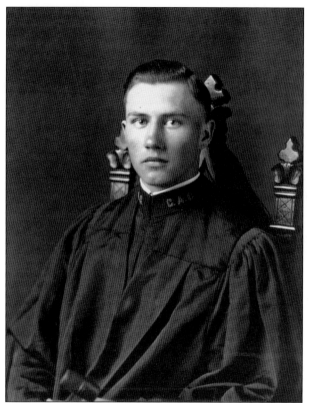

James Strom Thurmond, Class of 1923, shown here as president of the Literary Society, now holds 34 honorary degrees. Born December 5, 1902 in Edgefield, South Carolina, he was state senator from 1933 to 1938 and governor from 1947 to 1951. Elected to the United States Senate in 1954, Thurmond became the senate's longest serving member on May 25, 1997, and he cast his 15,000th vote in September 1998. His legacy to Clemson includes the Strom Thurmond Institute on campus that continues a commitment to teaching that began his phenomenal career in 1923 as a public school teacher in Edgefield County.

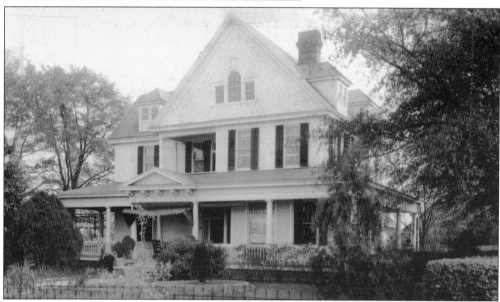

J. Strom Thurmond's birthplace in Edgefield—and the Senator's middle name—preserves the history of the Straum family that arrived in 1764 from Germany and settled in Ninety-Six District. Thurmond married Jean Crouch of Elko, South Carolina in 1947 and Nancy Moore of Aiken, South Carolina in 1968. He has four children—Nancy Moore (d. 1993), James Strom Jr., Juliana Gertrude, and Paul Reynolds.

This *TAPS* 1923 depiction of a friendship celebrates Clemson's diversity in unity at its best. Both Strom Thurmond and Nicholas Rickenbaker Till have similar backgrounds: ROTC training, both with German-Swiss roots, and both from planter family backgrounds. Thurmond was from Edgefield, studying horticulture, striving to "always be a man." Till was from Orangeburg, a civil engineer, determined to be "an honest man" as "a perfect work of God."

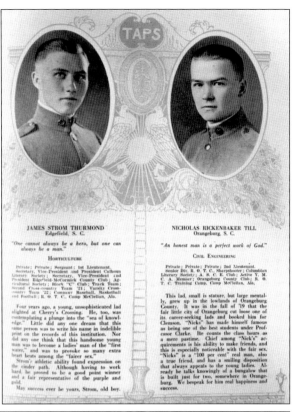

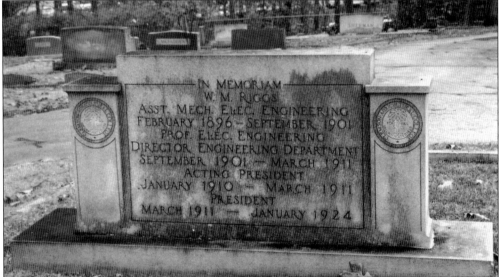

Pres. Walter Merrit Riggs died on January 22, 1924 at a meeting in Washington, D.C. The marker on Cemetery Hill preserves the memory of his devotion to Clemson. In his state-of-the-college report of 1910, he had written that Clemson's usefulness depended "upon full recognition of our obligation to carry the gospel of enlightened agriculture to every farm in South Carolina. When we do this, we will make Clemson College so dear, because so helpful, to the people that we will have no fear of the demagoguery which over the years sought to tear the college down."

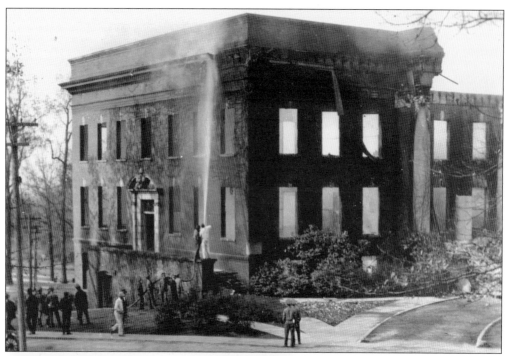

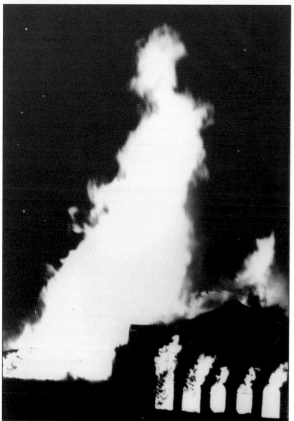

During the night of April 1, 1925 and immediately after the campus visit of the newly appointed president Enoch Walter Sikes, fire gutted the agricultural building, destroying research projects and the agricultural museum. Since the exterior remained largely intact, the structure was redesigned as Sikes Hall to hold Tillman Hall's library.

In 1921, the engineering department began moving its various components into a new addition to the Mechanical Hall's east wing, but on May 27, 1926, the roof over the machine shop caught fire and destroyed Mechanical Hall. Fire fighters from Anderson, Greenville, and Easley contained the blaze and saved the nearby fertilizer and chemistry buildings. A new shop building (Freeman Hall) was erected in 1926, the old electrical laboratory was torn down, and a new structure of reinforced concrete and steel rose on the site. (Walter Merritt) Riggs Hall was dedicated at commencement in 1928.

Four

RUNNING THE SHOW

A new and pragmatic era began with the presidency of Enoch Walter Sikes. Born 1868 in a rural Union County, North Carolina community, Sikes attended a one-room log schoolhouse and was the first in his family to get an education beyond high school. At Wake Forest College, he starred as a guard on the football team. In 1894, he entered the doctoral program at Johns Hopkins, studying history, government, and economics. Woodrow Wilson was one of his major professors. Sikes came to Clemson from South Carolina's Coker College, where he served as president from 1916 to 1925. Under his presidency, the Baptist women's school doubled its endowment and gained accreditation in 1923. He was ready to tackle Clemson's academic programs.

During his 15 years as Clemson's sixth president Sikes increased student enrollment from 1,087 to 2,227, increased the number of faculty from 83 to 163, added 10 bachelor's degree programs to the existing 9, made major changes in the academic administration, and gained Clemson accreditation in 1927 from the Association of Secondary Schools and Colleges of the Southern States. He also started the first graduate degree offerings at Clemson.

Among the changes Sikes effected was an emphasis on "The Individual Student," as he headed one section of his report to the trustees in 1932. National honor societies were permitted to establish chapters and the rules for cadets were relaxed. In a truly visionary move of 1926, a department of arts and sciences was formed that included modern languages. It was the basis for making Clemson truly a center of universal learning and global outreach. Two years later the textiles curriculum began emphasizing engineering and process management rather than vocational training. Between 1929 and 1933, a master of science degree in textile chemistry and dyeing were offered, as well as a new bachelor of science in agricultural engineering. Professional degrees in civil, mechanical, and electrical engineering were also added. Finally, the reorganization grouped programs into the six schools of agriculture, chemistry, engineering, general science, textiles, and vocational studies.

The Great Depression did not bypass Clemson. Student enrollment and income from the fertilizer tax dropped sharply. Salary reductions were implemented and tuition was raised from $40 to $60, but the New Deal also brought new construction to campus through the Works Progress Administration. Four new dormitories with room for 420 cadets relieved critical housing shortages. A new agricultural building (Long Hall) was built with federal assistance

and partial funding from the fertilizer tax. Federal funds also built a new textile building, now Sirrine Hall, and permitted the acquisition of 29,625 acres of privately owned farmland within a 10-mile radius of the campus.

A new era also began for the Tigers. Sikes separated the athletic program from the physical education department and hired Jess Neely from the University of Alabama for the 1931 football season. With Neely came his assistant coach, Frank Howard. Financial difficulties brought back memories of the 1899 Foot Ball Association's pledge and IPTAY was established in 1934. Once again, a look to the past shaped the future.

> While man does not live by bread alone, he cannot live without it.
> —E.W. Sikes.

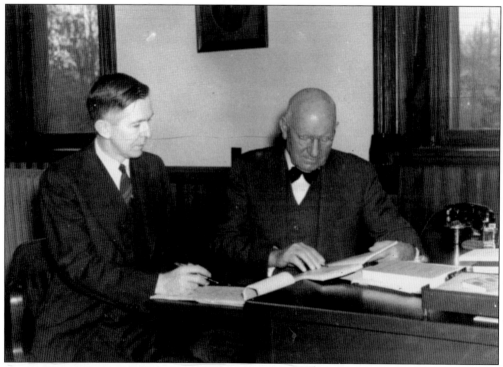

Pres. Enoch Walter Sikes (right) is pictured with his business manager, James Corcoran Littlejohn. A freshman engineering major from Union County in 1904, Littlejohn, after his graduation, became campus electrician, instructor, registrar assistant to President Riggs, business manager of President Sikes, and "faithful sidekick, friend and able boss" to President Poole.

This photo, originally belonging to Barton Walsh Jr., shows students G.C. McCelvy (Abbeville), H.B. Pitts (Sumter), and B. Walsh Jr. (Sumter) in room 155 of the first barracks. A relaxation of cadet regulations permitted civilian clothing after hours and visits by friends, as well as pictures and decorations in cadets' rooms.

A group of women from Coker College is on a campus visit. The Baptist institution in Hartsville, South Carolina was founded and endowed in 1866 by Maj. James Lide Coker and became a liberal arts college for women in 1908. Under the presidency of E.W. Sikes (1916–1925) the college gained accreditation in 1923—several years before Clemson.

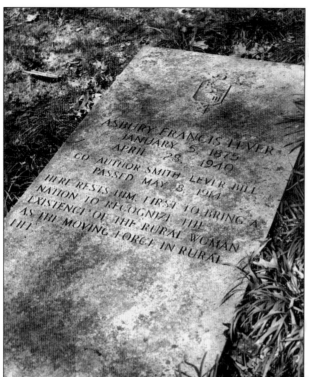

Asbury Frank Lever, Clemson life trustee (1913–1940) and United States congressman from South Carolina, co-sponsored the Smith-Lever Act passed on May 8, 1914, which was the foundation for the nationwide system of agricultural extension services. His marker on Cemetery Hill remembers him as the "first to bring a nation to recognize the existence of rural woman as the moving force in rural life."

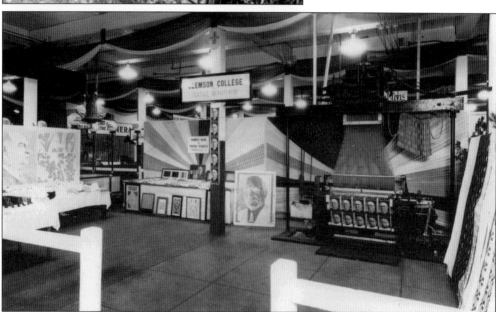

After the end of World War I, the textile department began working with the Institute for Textile Research. Clemson also participated in advanced overseas studies and by 1929 had a cooperative graduate program in textile chemistry with the University of Nancy in France. At home, the Textile School held exhibitions that paralleled the first engineering-architecture exhibit held in May 1932 (E-A Day). This exhibit in Greenville shows weaving and dyeing capabilities with a portrait of President Sikes.

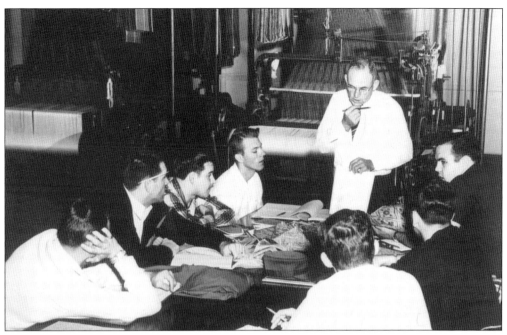

With diversification, Clemson's Textile School produced graduates who were easily placed even in the meager years of the Depression. Of its 109 graduates between 1930 and 1933, 105 had found jobs by July 1933. Artistic design drew on native South Carolinian skills. Note the design on the fabric sample to the right of the picture above and compare it with the quilt pictured below.

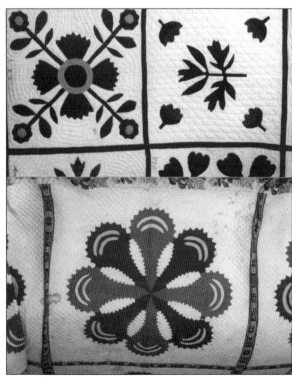

A quilt made about 1850 by women from the Rauch household shows a similar design to the one above. The quilt is currently located in the Lexington County Museum, which holds a large number of textiles crafted by women of German heritage in the Newberry and Lexington areas.

65

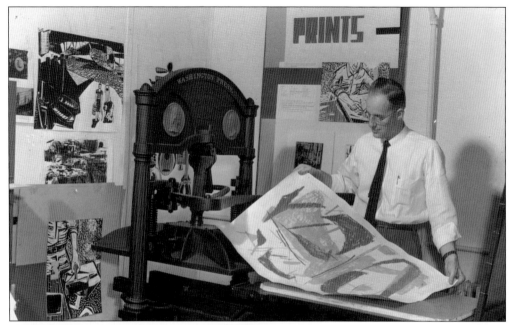

The engineering department became the beneficiary of technical programs in other departments such as textile and chemical engineering with research and extension services. Printmaking required the cooperation of several departments for skills in design, aesthetics, materials, and special equipment.

The Textile School began offering degree programs in industrial education and textile chemistry in 1927. This class in weaving and design shows hands-on instruction in 1944.

Rudolph E. Lee, member of the first graduating class and a life-long faculty member, is shown here in his office. Initially hired to teach mathematics, Lee later became head of the engineering department's drawing and designing division and functioned as college architect. He started Clemson's architecture program as a legitimate discipline and was in charge of the American Institute of Architects' (AIA) program for the upstate district.

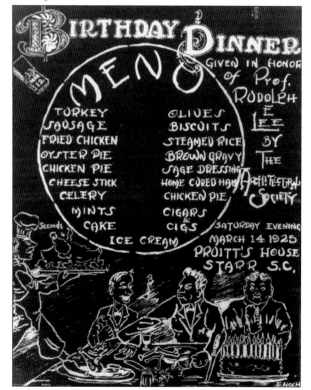

Here is the menu for Prof. Rudolph E. "Pop" Lee's birthday dinner given March 14, 1925 by the Architecture Society. As a cadet, he had helped commandant Donaldson organize "raw recruits into squads" and was a "ringleader" in the famous frolic of the 1893 rabbit hunt on the snowy grounds of Clemson.

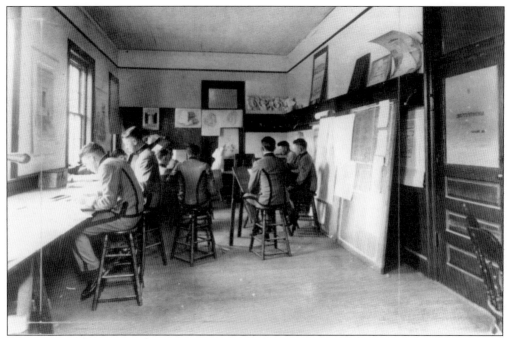

Programs leading to a bachelor's degree were offered by the School of Engineering in architecture and civil, chemical, electrical, and mechanical engineering. Architecture students worked on drawings, made models of buildings, and displayed building materials at exhibits. This class in freehand drawing was taken around 1930.

Ben Robertson (right, class of 1923) is shown with English professor John D. Lane. Robertson became one of Clemson's best-known journalists and authors. As reporter for the *New York Herald-Tribune*, the *Associated Press*, and the *Saturday Evening Post,* he traveled around the globe on assignment. During one of his frequent visits to Clemson, he wrote *Red Hills And Cotton: An Upcountry Memory*. It is a magnificent testimonial to his upbringing in upper South Carolina. Robertson died in a plane crash near Lisbon in 1943 and is buried in Liberty, South Carolina.

Wright Bryan (Class of 1926) also grew up on the Clemson campus and studied journalism at the University of Missouri like Robertson. His career began as Senior Editor of *The Tiger*, and spanned the editorship of the *Atlanta Journal* and the *Cleveland Plain Dealer*, until his return to Clemson as vice president of development in 1964.

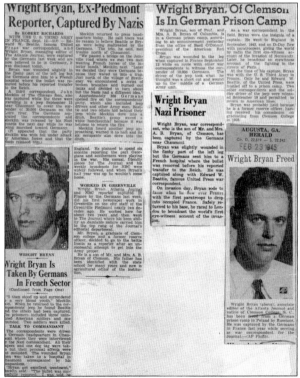

As a war correspondent for NBC, Wright Bryan presented the first eyewitness account of the Allied invasion on D-Day, June 6, 1944 to the world on radio. He made headline news when he was captured by the Germans in France and released only five months later. Wright Bryan's book *Clemson: An Informal History of the University 1889–1979* contributed much to this present history.

Harry Ashmore, class of 1937, became perhaps the most successful professional journalist taught by English professor John D. Lane, who was faculty advisor to *The Tiger*. Ashmore became editor of the *Greenville News* and then executive editor of the *Arkansas Gazette* in Little Rock. After serving on the nomination committee for the 1952 Pulitzer Prize in journalism, Ashmore received the coveted prize himself in 1958. The Pulitzer Prize committee commended Ashmore's "dispassionate analysis and clarity of his editorials" during the 1957 Little Rock integration crisis, and cited his paper for "the highest qualities of civic leadership, journalistic responsibility and moral courage in the face of great public tension." Harry Ashmore received the Distinguished Service Award of the Clemson Alumni Association in 1967.

The staff of *TAPS,* Clemson's annual yearbook, is shown in this 1934 photograph.

These are reporters for Clemson's *The Tiger*. The student newspaper, founded in 1907, had Samuel R. Rhodes as its first editor. A number of its student editors later distinguished themselves as journalists and writers. Besides Ashmore, Bryan, and Robertson (above), George Chaplin (class of 1935), chief editor of the *Honolulu Advertiser*, and Earle Mazo, editor of *Readers' Digest*, deserve mention. Clemson English teachers like Professors John D. Lane and Louis L. Henry served as faculty advisors for many years and taught them well.

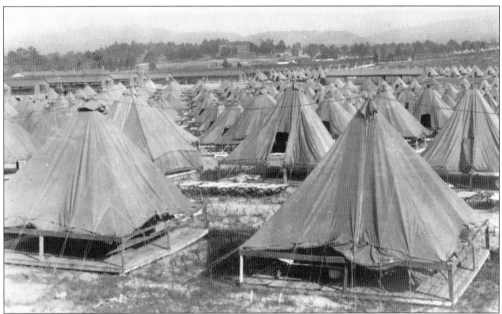

Clemson cadets went on maneuvers to Camp McClellan at Anniston, Alabama. Gen. C.P. Summerall, head of the Citadel in Charleston and the army's chief of staff from 1926 to 1930, initially negotiated the camp's purchase, which received its first troops in 1917. In the mid-1920s, the camp became an army post for only one infantry regiment, but with a standard layout summer camp for 6,400 civilian trainees. This Clemson photo was made in 1925. In January 2000 the army property went on sale for civilian reuse.

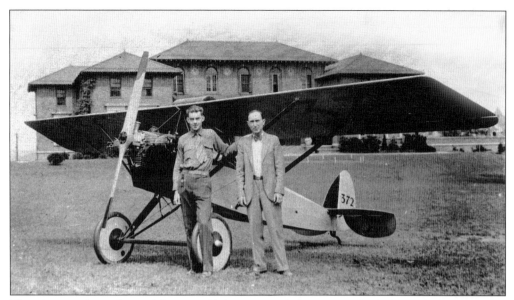

The 10 original members of the Aero Club, organized about 1928, built the 17-foot monoplane "Little 372" under the keen eye of woodworking professor John Logan Marshall (right). Marshall also led and guided the formation of the Tiger Brotherhood in 1927. The Aero Club disbanded during the Depression, but a civilian pilot training program was approved at Clemson by the Civil Aeronautics Authority. In 1939, the Clemson Flying Cadets were organized with Professor Sams as faculty advisor.

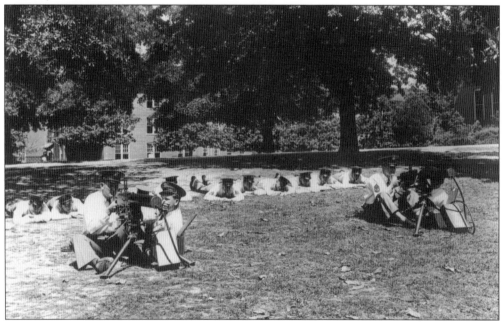

The Reserve Officer Training Corps (ROTC) was established by the National Defense Act of 1916 and Clemson had a unit in 1917. This group is training in 1937. The ROTC continues Clemson's military service tradition with its Pass-in-Review long after the Cadet Corps (1893–1955) and the Senior Platoon, an elite military precision drill team (1929–1960), had ceased marching at bowl games and parades.

Preston B. Holtzendorff Jr. (right), for whom the Holtzendorff YMCA was named, came to Clemson as the YMCA's assistant secretary in 1916 and soon became general secretary. In 1927, talking pictures had just arrived and "Holtzy" instituted a weekly free movie at the "Y" on Friday afternoon and Saturday. On Sunday nights he held vesper services with prayer, singing, or a well-known speaker. One Sunday night in December 1932, news came that the Presbyterian Church was on fire. Holtzendorff told the assembly to get buckets and help save the church. The "Y" also had the only swimming pool on campus, ping-pong tables, and pool tables in the main lobby for 5¢ a game.

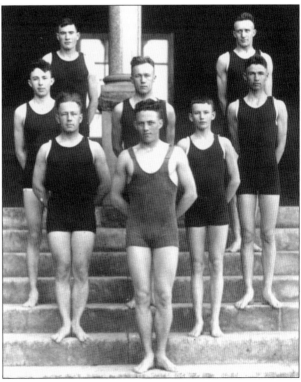

The swim team is now (2018) defunct (first years)

The men's swim team is shown in their vintage suits.

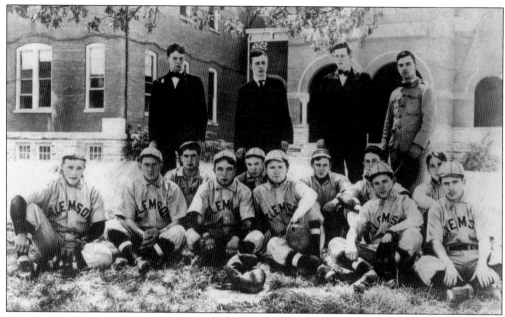

Baseball, football, military drills, and parades were held on Bowman Field until Riggs Field was dedicated in 1916.

This much later photo shows Olson pitching on Riggs Field. Spectators numbered in the hundreds at most, watching from the sidelines or cars.

In 1925, college and high school basketball games were played at the Holtzendorff gymnasium. The "Y" also had locker rooms, billiard and game rooms, and a snack bar. Holtzendorff Hall, built with funds from the fertilizer tax and a grant from John D. Rockefeller, was the first campus building constructed with private funds. It functioned as a student center.

During the Great Depression, Clemson was once again in need of financial support for athletics. In 1934, a group of alumni in Atlanta formed an organization called IPTAY (I Pay Ten A Year) to raise funds. With the assistance of football coach Jess Neely, who came to Clemson in 1931 from Alabama with an assistant coach named Frank Howard, 162 members contributed $10 each during the first year of IPTAY's existence. The marker of Dr. Rupert Howard Fike in Woodland Cemetery shows the justifiable pride in this venerable Clemson tradition.

The 1920s and 1930s also saw a beginning outreach to industry. These 18 Clemson alumni were employed in the late 1920s at the Schenectady plant of General Electric. Pictured from left to right are (front row) F.E. Thomas, Oscar Roberts, St. Julien E. Bell, Donald Livingston, W.A. Holland, John Klenke, Harry Hood, F.E. Dunham, and George Ricker; (back row) H.D. Penge, T.S. Gandy, T.F. Barton, G.B. Holland, W.P. White, F.O. Berry, B.B. Guy, Joseph Chambers, and Chandler Ricker. In 1933, Glyco Products in Brooklyn gave fellowships to students in the Textile School.

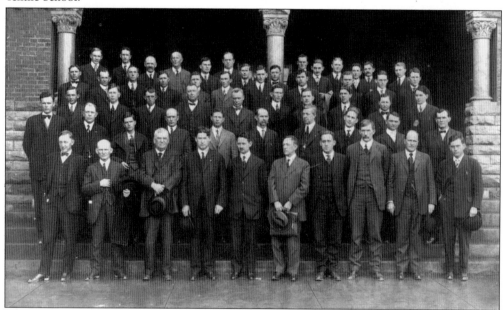

During the Depression, Clemson's agricultural engineers diversified the Extension Service's outreach to educate farmers on soil erosion, conservation, and crop storage techniques. A major program involved rural electrification. In 1937, about 16,000 farms in South Carolina had electricity—four times as many as in 1934. The photo shows a meeting of Agricultural Extension agents at Clemson.

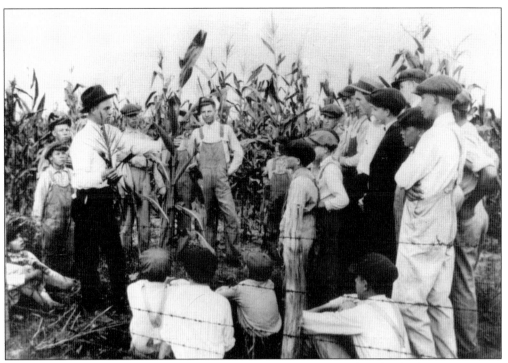

This is a photo of a Clemson Agricultural Extension engineer at work in the field.

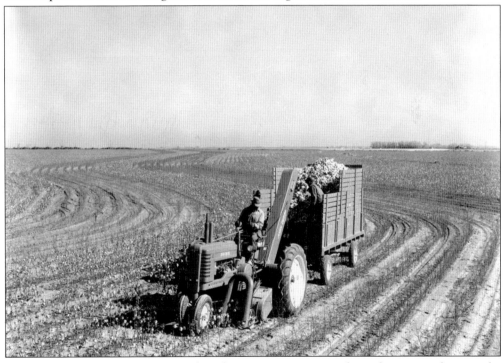

A cotton picker machine is pictured in the Lowcountry. As machines began to take over the backbreaking work of cotton picking, the farming and textile industries changed forever from labor-intensive to capital investment strategies.

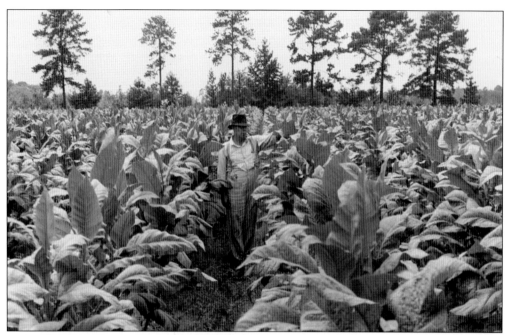

South Carolina Burley Tobacco was a cash crop of substantial income to farmers and was assisted by Clemson's research and extension services. The town of Mullins in the Pee Dee area began growing and harvesting tobacco in 1894 and became the largest tobacco market in the state. A documentary video, *When Tobacco Was King,* produced in October 2000 by the Tobacco Museum in Mullins in cooperation with Clemson University, focuses on the growing of tobacco and rural farm life before 1950.

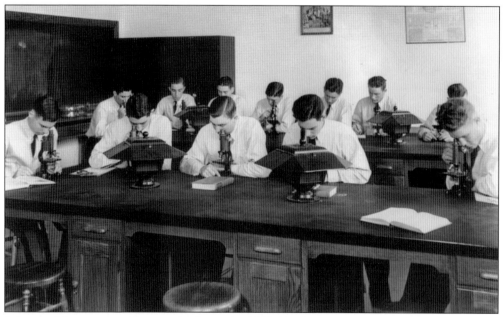

A botany laboratory at Clemson is shown in 1937. To increase agri-systems productivity, the analysis of fertilizer samples, eradication of crop pests, and development of plant resistance to disease were part of a student's agricultural economics and science education.

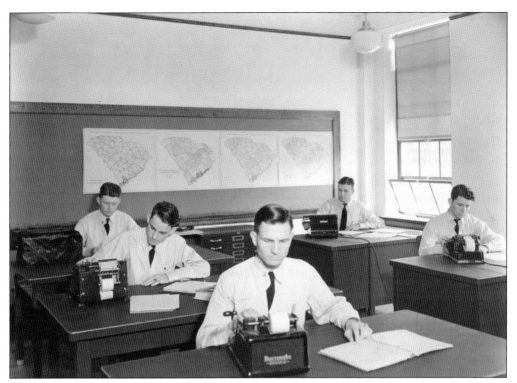

These students are in a 1937 statistical laboratory class in agricultural economics.

In 1932, immediately after the degree program in agricultural engineering was established, a student chapter of the American Society of Agricultural Engineers was formed at Clemson. George B. Nutt (top row, right) headed the new department.

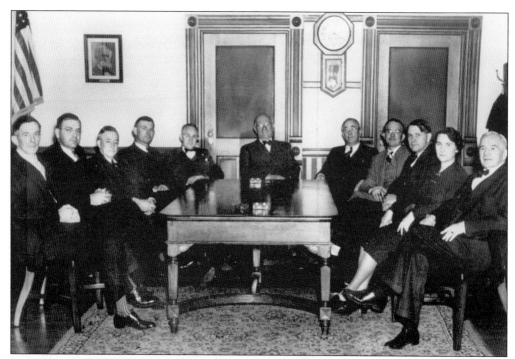

Shown here is a meeting of the deans and directors in 1939 with President Sikes. At the right is Cornelia Graham, head of the library.

This is the 1940 graduation at the Amphitheater. This splendid outdoor stage was constructed with a gift from the Class of 1915 and WPA funds. The inauguration ceremonies of Pres. James F. Barker were also held there.

Frank Howard, shown with his team, came to Clemson from Alabama in 1931 with Jess Neely and succeeded him as Clemson's Head Coach in 1940. Winning the Southern Conference championship—the first of eight conference titles in his coaching career—Howard went on to his most successful season in 1948, when he took the Tigers to their first perfect season since 1900. Memorial Stadium, completed in 1942, commemorates one of Clemson's most revered coaches with "Howard's Rock." At his retirement in 1969, Frank Howard was the nation's fifth "winningest" coach with 165 victories and had been selected twice as the ACC Coach-of-the Year. He was inducted into the College Football Hall of Fame in 1989.

The only Clemson athlete to achieve All-American status in both football and basketball in the same year (1939) was Banks McFadden, who once held three South Carolina track and field records and was named the nation's most versatile athlete for 1939–1940. McFadden was elected to the National Football Hall of Fame in 1959, played in the NFL, coached the defensive backs at Clemson for 26 years, and was head basketball coach from 1947 to 1956. The McFadden building was named in his honor in 1995.

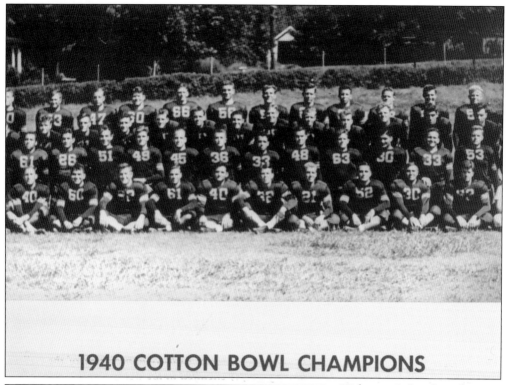

1940 COTTON BOWL CHAMPIONS

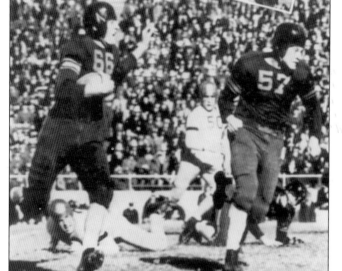

With permission from the Southern Conference, Jess Neely's last Clemson team with an 8-1 season accepted an invitation to the Cotton Bowl to play Boston College on January 1, 1940 for Clemson's first bowl appearance. The Tigers were led by All-American Banks McFadden who averaged 44 yards a punt, had 4 pass deflections, rushed for 33 yards, and passed for 35 more in a 6-3 win over the Boston College Eagles. This tremendous victory was also a fitting tribute to Enoch Walter Sikes' 15 years of superb leadership. President Sikes retired in July 1940 and died without apparent warning on January 8, 1941.

Five

A TIME
OF TRANSITION

When Robert Franklin Poole, the first Clemson alumnus to become president of the college, took office in July 1940, Europe was already deeply engulfed in the World War II. Poole, son of a Laurens County farm family, had graduated in 1916 with a diploma in botany, received an M.S. and Ph.D. from Rutgers University and was assigned to a unit of aerial photography in World War I. Poole cherished Thomas G. Clemson's humanitarianism and hoped for a return to "instruction to embody the theory and basic learning" and the "practical concepts of these." Shortly after his inauguration, in a speech given at the Rotary Club in Greenville on October 1, 1940, he looked back to antebellum prosperity and a time when "the people of the southern states maintained a superior atmosphere." Before the Civil War, he said, the "bulk of the food consumed in the South was produced on its lands," not in the Midwest and California. The southern educator's task was to "fit the man in his proper vocation and educate him to meet its tasks," and his aims involved "searching for men to become cogs in the wheels of society and industry." Poole drew strength from the viewpoints of his youth and thought it impossible "that partisan politics and army politics will have a part in dictating the defense program."

Pearl Harbor ended the dream of a war to end all wars. James F. Byrnes, life trustee of the Clemson board, oversaw the war mobilization efforts for the United States and more Clemson officers entered the army during the first two years of the war than from any other American institution except Texas A&M. The death of alumni on active duty were reported in The Tiger, *and speculation on "Ben" Skardon (class of 1938) and Henry D. Leitner (class of 1937), who were missing in the Philippines, abounded. In 1943, all able-bodied students of military age had left the campus and Sirrine Hall's basement received the first contingents of 1,000 Army Air Corps cadets for flight training. Faculty, too, were on military leave, and those remaining often taught courses outside of their field of expertise.*

President Poole was a well-known plant pathologist with an orthodox Southern philosophy but little interest in managerial duties. He left solutions to management problems, such as the procurement for housing and classroom space for the 2,700 students the college expected in 1946, mostly to James Littlejohn. Yet, the end of the war dictated major changes in the college on its way to becoming a university. When Littlejohn retired in 1955, the board adopted the restructuring recommendations made in the management study of the nationally known firm

Cresap, McCormick, and Paget. Poole was cautioned to refrain from making recommendations that conflicted with the firm's report. Veterans' reluctance to participate in routine cadet exercises led to the official decision on July 18, 1955 to end the required military training at Clemson and permit the college to become co-educational. Undergraduate women were admitted in the second semester of the academic year 1954–1955. However, African-American veterans wishing to attend Clemson on the GI Bill of Rights were not accepted, and as late as 1958, Clemson's tennis team refused to play North Carolina State who had a black team member.

Poole told the trustees that the college needed a graduate school, and he suggested the construction of a 15,000-seat stadium. He agonized over the end of the cadet corps, co-education, the expanded role in student affairs, the new administrative structure, the acceptance of African-American students, and the impact on Clemson's property by the Army Corps of Engineers' plan to create Lake Hartwell. But in the end, he was not prepared to negotiate with the corps. He seemed overwhelmed by the speed and magnitude of the changes taking place on campus. The trustees sought Poole's retirement with a decree effective June 30, 1957, making retirement mandatory at age 65 for all Clemson personnel, but Poole died of a heart attack on June 6, 1958 before questions about his retirement were settled.

> We have got to stop drinking wet and voting dry.
> —R.F. Poole

Chemistry major Margaret Marie Snider, class of 1957, was the first Clemson co-ed graduate. Twenty-six women enrolled in the second semester of the 1954–1955 session.

Shortly after the attack on the World Trade Center on September 11, 2001, Clemson honored surviving heroes of its past. The following are pictured from left to right. Retired Air Force colonel William R. Austin II was shot down near Hanoi in 1967, captured and tortured in Vietnam, and survived to become Head of Aerospace Studies at Clemson. Lt. William Funchess, wounded in Korea and imprisoned for three years, returned to supervise extension services as associate professor of agronomy at Clemson. Col. Ben Skardon, Japanese POW in World War II, survived the infamous "Death March" and received Clemson's Alumni Master Teachers Award. Retired Navy commander Robert S. Fant Jr., shot down over Vietnam in 1968, wounded, and then imprisoned for nearly five years, continued his professional career instructing Navy and Marine Corps Air Crews. Dr. Bill Hunter, a football player under Coach Howard and freshman electrical engineer, was put in flight surgeons' school in World War II. A past president of the South Carolina Medical Association and Distinguished Alumnus of Clemson and MUSC, he holds the 1947 Duquesne vs. Clemson game ball at the Memorial Stadium ceremony.

The Class of 1939 Award for Excellence, Clemson's highest award, is presented annually at the Class of 1939 Bell to a distinguished member of the faculty whose contributions for a five-year period represent the highest achievement of service to the university, the student body, and the larger community within the town, the state, or the nation.

The entire memorial complex, including the Class of 1939 Bell, the Carillon Garden (class of 1943), and the Memorial Square (class of 1944) in front of Mell Hall, beautifies the campus and honors Clemson's past and present military service to the nation. Completed in 1993, the area also symbolizes the link between past, present, and future in the university's progress toward ever greater distinction.

The sculpted sentry guarding Bowman field reminds today's sunbathing, football-playing, and float-building students of the decades of military parades held there; but the classes of the World War II years (1939–1945) have contributed much more than these memorials. They gave for the future and contributed significantly to the creation of endowed chairs, endowed scholarships, and academic programs. Between 1985 and 1994, the university's endowment increased from $22 million to $90 million.

Clemson Agricultural College also honored its fallen soldiers with the Through Truss Bridge that spanned the Seneca River on old Highway 123. Built in the 1930s, it served as an example of this type of construction for Clemson students and was dedicated after World War II as a memorial "to the men of Clemson College who gave their lives during the World War." The bridge was dismantled when Lake Hartwell was created.

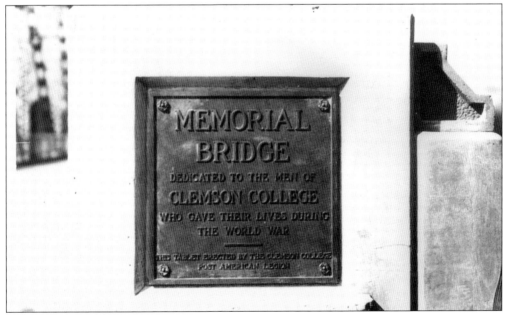

The tablet was placed on the bridge by the Clemson College Post American Legion. Clemson also had a "Memorial Grove" with rows of poplars equal to the number of "Gold Star" Tigers. A granite memorial marker was later moved to the east side of Highway 93 at the traffic light to the East Campus.

Strom Thurmond (standing, right) proudly points to a bull's eye shot. Thurmond experienced World War II duty from 1942 to 1945 with the First United States Army in the American, European, and Pacific Theaters. He landed in Normandy on D-Day with the 82nd Airborne Division and earned numerous decorations during his service, including the Purple Heart and the French Croix de Guerre.

A machine gun company is shown on maneuvers at the Seneca River.

Ben Robertson (class of 1923) is pictured during one of his visits home to Clemson. While here, he wrote the classic memoir *Red Hills and Cotton* (1942). Among his many World War II reports, the noted journalist covered the Battle of Britain for the New York paper *PM*, retold in his book *I Saw England*. On February 22, 1943, Robertson was on his way to head the London office of the *New York Herald Tribune* when his plane crashed near Lisbon. His body was flown home to Clemson for a funeral in the college chapel. Robertson's grave marker in Liberty, South Carolina bears his own words: "I rest in thy bosom, Carolina, Thy earth and thy air around and above me. In my own country, among my own, I sleep."

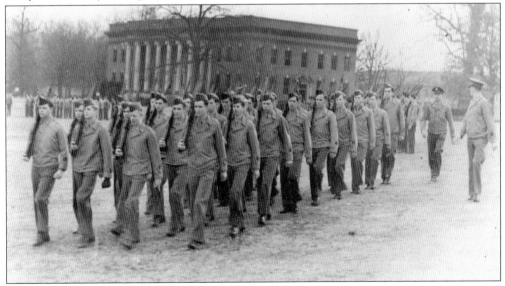

World War II troops are shown drilling on Bowman field with Sikes Hall in the background.

Shown here is a post World War II drill in front of the Holtzendorff YMCA.

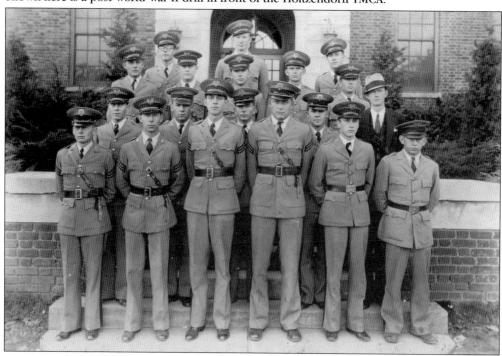

Agricultural engineering students are pictured in uniform. Among professors who served in the armed forces during the war were James H. Sams (mechanical engineering), A.M. Quattlebaum (civil engineering), E.B. Therkelson (electrical engineering), W.M. Wachter (mechanics and hydraulics), D.W. Bradbury (drawing), and George H. Dunkleberg (agricultural engineering). Dunkleberg, who was with the 101st airborne division, was imprisoned at a German POW camp in Poland and returned to the American army in 1945 by the Russians.

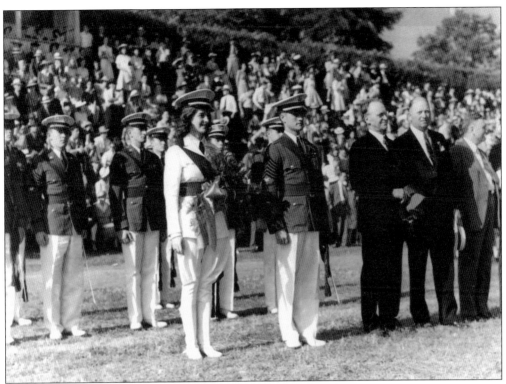

The Corps of Cadets chose a female honorary corps commander or honorary cadet colonel for special occasions, such as full-dress parades on Armed Forces Day. This photo shows Hon. Cadet Col. Wylene Pool in 1942.

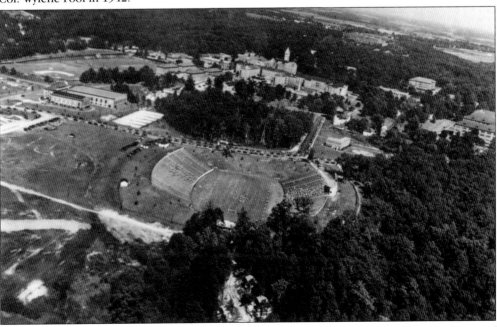

This aerial view of the Clemson campus was taken about 1943, shortly after completion of Memorial Stadium. Note the football game in progress.

The class of 1943 was the smallest in Clemson history with 343 graduates, and it was the last class allowed to graduate in World War II. Juniors were urged to remain in college, seniors to choose between ROTC and enlisted reserve. This photo shows freshman registration about 1943.

In 1943, with Clemson life trustee James F. Byrnes acting on the war mobilization effort for President Franklin D. Roosevelt, Clemson contracted with Army Signal and Air Corps units for their specialized training, medical care, housing, and feeding before they rejoined the front lines. The federal government paid more than $1 a day for meals, while regular students paid only about 65¢. In this picture, from left to right, are Earle Roberts, Chuck Tebeau, T.C. Moss, Bob Brooks, Dick Morrow, and Walker Gardiner riding a vintage cannon.

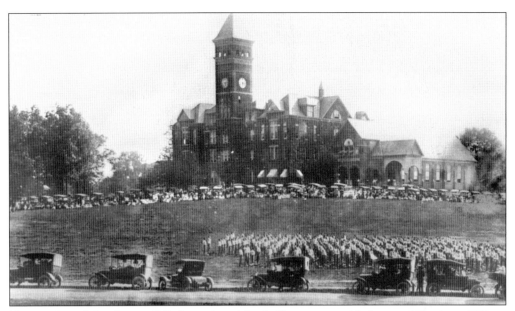

The routine of the Corps of Cadets reigned for half a century with few modifications. Military order prevailed throughout the day, starting with reveille (initially at 0630 hours, but from the 1920s on, at 0700) and followed by breakfast, guard mount, surgeon's call, and compulsory chapel at 0810. Cadets were marched to and from class recitations by officers at 0830 to 1230 and from 1400 to 1600 hours. Drill period, initially every day at an arranged hour, was later set from noon to 1300 hours three days a week, followed by dinner. Supper was taken after retreat at sundown. After a half hour of recreation, study period commenced and lasted until 2200. *TAPS* at 2230 meant lights out and cadets required to be in bed.

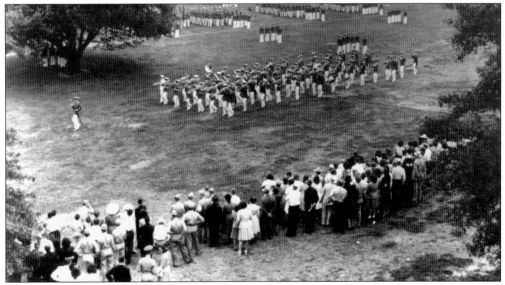

The Mother's Day parade in 1943 was bittersweet. The draft age was lowered in March to include men 18 and 19 years old, subject to special exceptions. While *The Tiger* echoed the administration's advice that patriotism meant to continue normal duties until called, the first Clemson man definitely confirmed a prisoner of war was Capt. Wesley McCoy Platt (class of 1935). Clemson casualties continued to rise.

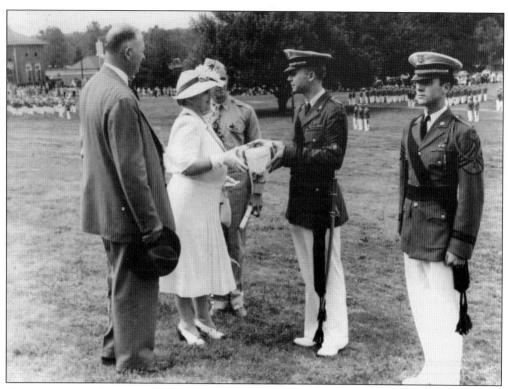

The photo shows Cadet Col. L.D. Rogers receiving the DAR medal on Mother's Day 1943. Local chapters of the Daughters of the American Revolution and the Daughters of the Confederacy were founded during the Mell administration.

When President Franklin D. Roosevelt died on April 12, 1945 at the "Little White House" in Warm Springs, Georgia, World War II drew to a close. The nation was stunned by the president's sudden death, and when his body was taken by train through the southern states to Washington, countless people turned out to watch it pass. At the Clemson Railroad Station, cadets stood at attention and children climbed to higher ground for a better look. In Greenville, children began singing "Onward Christian Soldiers," and the crowd—some 10,000 strong—joined in. Clemson acquired more than 25,000 acres of land within a 10-mile radius of campus through a government project begun as a New Deal program during the Roosevelt administration.

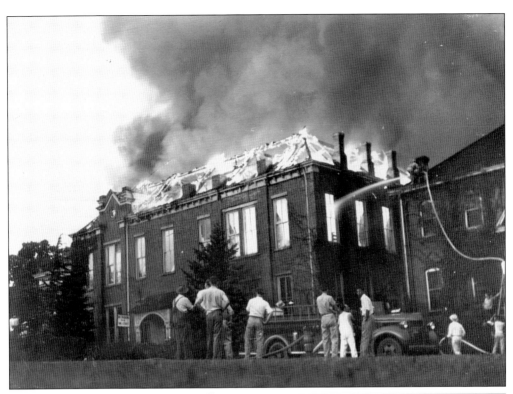

The ornately gabled roof of Hardin Hall, the original chemistry building, caught fire in 1946. With the assistance of Upstate firefighters, the oldest classroom building on campus was saved except for damage to the upper levels. Hardin Hall is currently undergoing major renovations.

This certificate, signed by the upperclassmen of Company M, states that freshman Mattox successfully completed "Rat service" in AY, 1947–1948. "Rats" endured hazing, shaved heads, and were required to perform services for upperclassmen that sometimes resulted in severe punishment if not performed as requested. One "Rat" duty was to memorize the names of upperclassmen on pain of paddling. Richard Mattox, owner of this certificate, became Clemson's Director of Admissions and served until 1987.

In spite of hard times, Tiger spirits remained high between the times of this snapshot from the 1920s and the design of Memorial Stadium by H.E. Glenn and Carl Lee (Class of 1908) of Charlotte.

Clemson Memorial Stadium (shown c. 1949) opened on September 19, 1942 with the Tiger's 32-13 win over Presbyterian College (PC). Lonnie McMillan, one of PC's coaches, is credited with naming it "Death Valley" for the many years his teams were defeated there. "Howard's Rock" was given to the coach by S.C. Jones, who picked it up in Death Valley, California. The original stadium of 20,000 seats was built with the help of scholarship athletes, including many football players, at a cost of $125,000 or $6.25 per seat. They were rewarded by Coach Howard with 50 gallons of ice cream consumed on the field at completion. Memorial Stadium was built for the future—additions in 1958, 1960, 1978, and 1983 increased capacity to over 80,000. Cost per seat in 1983 was $866.

Two victorious statesmen of Clemson fame at the Carolina vs. Clemson game in October 1947 were James F. Byrnes and Strom Thurmond. They are pictured with their significant others, Mrs. Byrnes and Jean Crouch of Elko, South Carolina. Byrnes resigned as secretary of state in 1947 and published his book *Speaking Frankly*. Thurmond was elected governor of South Carolina and married Jean Crouch on November 7.

President and Mrs. Poole and Governor and Mrs. Thurmond are shown at the Gator Bowl, January 1, 1949. Mrs. Poole, the former Sara Margaret Bradley, was the niece of both English professor Mark E. Bradley and W.W. Bradley, Clemson life trustee and board president from 1935 to 1948.

James F. Byrnes, a Charleston-born statesman and life trustee of the Clemson board, resigned in 1942 as associate justice of the United States Supreme Court to assist President Franklin D. Roosevelt as head of federal agencies for economic stabilization and mobilization during World War II. He was appointed secretary of state in 1945 by President Harry S Truman and represented the United States at the post-war peace talks. Although officially retired, this 1961 photo shows Byrnes (left) at the famous Kurfürstendamm in Berlin. Clemson's James F. Byrnes collection, adjacent to the Byrnes Room in Cooper Library, numbers more than 182,000 items of his papers and correspondence.

This model of the Confederate submarine *Hunley* was built in 1961 by Clemson industrial engineering students. It is currently at the State Museum in Columbia. A smaller model stands in front of the Charleston Museum. The original *H.L. Hunley* was built in 1863 by Park and Lyons of Mobile, Alabama. On February 16, 1864, the *Hunley*'s crew of nine successfully torpedoed the 1,800-ton USS *Housatonic* in Charleston Harbor and became the first submarine to sink a ship in wartime. The *Hunley* and her crew also perished. On August 8, 2000, the submarine was hoisted from the harbor bottom. She is currently at the Warren Lasch Conservation Center in Charleston.

During wartime, women began to fill production jobs formerly held by male workers. In 1942, *The Tiger* reported that seven local women were enrolled in vocational welding and metalworking courses at Clemson's School of Engineering. A 27-week course for women was also planned in engineering, with those passing to receive a diploma but no college credit. This qualified them for work as junior engineers at the war department or civilian agencies with annual wages of $2,000 (same as for men), but it was expected that they would give up the jobs after the war had ended.

The honorary cadet colonel and her escort are shown on Armed Forces Day, May 17, 1962. Women were not admitted to Army ROTC until the early 1970s.

The proceeds of the fertilizer tax initially assigned to Clemson were diverted to the state treasurer in 1947, but Clemson continued fertilizer inspection and analysis. In November 1959, *The State* quoted B.D. Cloaninger, director of the service, that 5,655 samples were taken in the past fiscal year from 890,302 tons of fertilizer sold in the state. The paper refers the reader to Clemson's Bulletin 473, *Inspection and Analysis of Commercial Fertilizers in South Carolina*, for complete information on this lucrative commodity.

The electrical laboratory is shown here in about 1956 with students Neil Phillips, Sam Moore, Sam Gambrell, Jimmy Merck, and Bill Gladden.

The biennial Engineering-Architecture Fair was revived in 1950, while agricultural engineering preferred to participate in the Agricultural Fair. Farm machinery, buildings, and exhibits on soil conservation and rural electrification were popular. This photo shows an aerial view of the Farmer's Week Exhibition on Bowman Field in 1951.

Professors Thomas W. Morgan (left) and George B. Nutt are pictured here at the 1950s Farm and Home Week displays. Morgan was associate director of the South Carolina Extension Service. In his manuscript *The First Fifty Years of Smith-Lever Extension*, he wrote that to help people help themselves, "results must be written on the soil." Agriculture students had to take at least one of the courses Nutt taught—Farm Machinery and Equipment and Surveying and Drainage. Nutt was director of extension at Clemson.

In 1955, Harlan E. McClure, graduate of the Royal Swedish Academy and MIT, was hired to head the department of architecture, then still housed on the third floor of Riggs Hall. He became dean of the newly created School of Architecture when it moved to its new quarters in Lee Hall in 1958 and expanded a rigorous curriculum to six years. Under McClure's guidance, Clemson's architectural program achieved a level of quality recognized around the world, and in 1969 the school was designated a college. The Charles E. Daniel Center for Building Research and Urban Studies was established in 1972 in a historic edifice in Genoa, Italy. President James F. Barker, himself a former student of McClure, succeeded him in 1986 as dean. McClure died on November 1, 2001.

Agricultural engineers were designing to "Change the World," too. This photo from the 1950s shows, from left to right, Bill Jones, B.K. Webb, E.B. Rogers, and A.W. Snell. Following the energy crisis of 1977, Professor Snell studied solar and earth-sheltered homes with grants for the exploration of alternative energy sources.

Six

THE ROARING FIFTIES AND THE WINDS OF CHANGE

During the administration of Robert Cook Edwards (1958–1979), the last of the presidents in the time period covered by this book, Clemson made enormous steps toward its future potential. A Clemson alumnus in textile engineering, Edwards began his career in textile manufacturing with J.P. Stevens in Greenville, became plant manager of Abbeville Mills—a division of Deering-Milliken,—and accepted a position as Clemson's vice president for development in 1956. On June 11, 1956, the trustees also adopted a report by Lockwood-Greene, an engineering firm in Spartanburg that detailed the devastating loss of property Clemson would incur by the proposed construction of the Hartwell dam by the Corps of Engineers. One of Edwards's first jobs was to avert the flooding of 9,000 acres of Clemson land, including 1,600 acres of the agricultural experiment programs' bottomlands, and prevent relocation of many campus buildings, facilities, and the stadium. After considerable negotiations with the corps, involving a modified diversion of the Seneca River and the construction of dikes, Edwards reached final terms of a settlement of $1,150,000 that purchased the property for the Simpson Agricultural Experiment Station.

Named acting president after Poole's sudden death, the trustees unanimously chose Edwards as Clemson's next president on April 9, 1959. Within months the college's policy of racial segregation—illegal since the Supreme Court decision in Brown v. Board of Education on May 17, 1954—was challenged once again, this time by Harvey Bernard Gantt, a black Charlestonian who requested information on Clemson's architecture program. Although previous applications by Spencer Bracey (1948), John L. Gainey, and John Lonny Dease (1956) had been rejected, Gantt's persistence, federal court action, and Supreme Court appeal won him admission. On January 28, 1963, amid extensive security arrangements, Harvey Gantt entered Tillman Hall to become the first student to break racial barriers at Clemson. It happened peacefully and honorably, without the turmoil and violence of the Mississippi and Arkansas integration crises.

The third major event of Edwards' administration was the institution's changeover to university status. With the advent of co-education and the abolition of required military

training, Clemson's academic emphasis changed. Science programs were upgraded, the first doctoral degree was awarded in 1958, and the nationally accepted tripartite mission of teaching, research, and public service for colleges became the rule for Clemson. In 1963, the governor and the presidents of South Carolina's public colleges agreed to change Clemson's name from Clemson Agricultural College to Clemson University. The will of Thomas G. Clemson, specifying the name Clemson Agricultural College, seemed to legally prevent this move, until history professor Ernest M. Lander Jr. found Creighton Lee Calhoun, the lone living descendant of T.G. Clemson, who happily endorsed the change. On March 11, 1964, the governor signed the measure into law, and Clemson was officially a university.

These years laid the foundation for Clemson's future in the 21st century. At the end of R.C. Edwards' presidency Clemson had 11,000 students. More than two-thirds of its faculty of 1,000 held terminal degrees. A college of Liberal Arts had been established in 1969 and Clemson's four "schools" had proliferated to nine "colleges" in 1979, offering more than 60 majors. Many dormitories, Redfern Student Health Center, R.M. Cooper Library, Strode Tower, Daniel classroom building, Littlejohn Coliseum, and Rhodes Engineering Center had transformed the face of the campus. During his tenure as Clemson's president, Edwards conferred 28,750 diplomas upon a greatly diversified student population.

> The key to evolving beyond our low-tech, assembly line roots is the development of world-class research universities.
> —Darla Moore

President Edwards is caught on camera with the Tiger at a pep rally.

Rudolph E. Lee, whom Lee Hall honors, was a member of the first class and lifelong member of the faculty and staff. Initially he headed the drawing division of the School of Engineering and served as college architect and supervisor of campus construction. The architecture department, as it emerged under his leadership in the 1930s, also offered art history and sponsored exhibits. During the war years, Lee was in charge of the Upstate's activities of the American Institute of Architects (AIA). In 1958 architecture was separated from engineering. It is now the College of Arts, Architecture, and Humanities.

The French École des Beaux Arts heavily influenced architectural education in America during the first decades of the 20th century, until contemporary needs began to favor architectural styles such as those emanating from the German Bauhaus and other European schools of thought. Dean McClure embraced the modern approach, but retained the French tradition of an annual Beaux Arts Ball featuring eccentric costumes. The photo shows Dean and Mrs. McClure (center) on such an occasion.

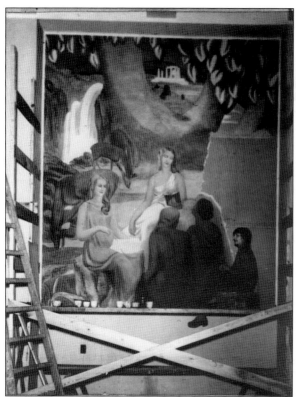

During the Christmas holidays of 1949, the fresco "Meditation In Arts" was painted by Robert LaMontaigne St. Hubert and his wife in the library (now Sikes Hall). In a thematic variation of the mythological muses—the fine and liberal arts—St. Hubert stressed the need for reflection (to muse) in the hectic pursuit of money. Presenting his work, he said, "I am by no means decrying business, but it is doubtful if either pure science or music or art would have existed in a world entirely made up of business men." Ironically, the mural is in the current bursar's office.

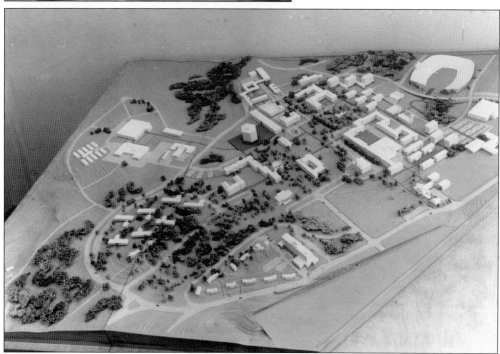

Building construction models such as this one is the bane and pleasure of many a sleep-deprived student of architecture.

Sara Skelton and Merrill Palmer (mathematics) usher in the computer age at Clemson's first computer in 1961.

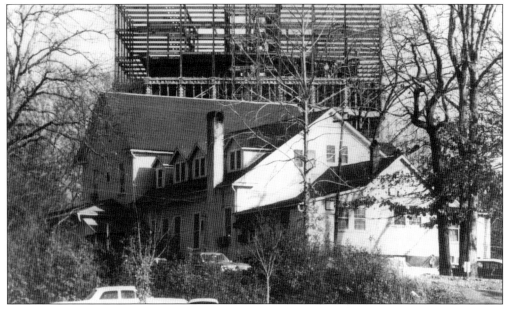

A majority of the major structures on campus were built during the Edwards administration. When Clemson became co-educational, increasing numbers of women students (158 in 1963) required the construction of the first women's dormitory and high-rise dorms that now dwarf older buildings on campus. Other edifices erected during Edwards' presidency were R.M. Cooper Library, Strode Tower and the adjacent Daniel classroom building, Redfern Student Health Center, the College of Nursing, Littlejohn Coliseum, the F.J. Jervey Athletic Center and more.

In 1954 Clemson won its first ACC baseball championship with an 8-4 ACC regular-season record in the conference's inaugural season.

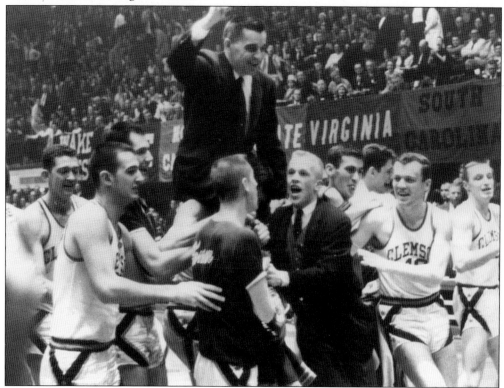

Clemson upset North Carolina State University (shown in the photo) and Duke University in the ACC basketball tournament of 1962 and advanced to the ACC championship game for the first time in the school's history. Jim Brennan gave a great Clemson performance in this historic tournament, scoring 34 points in the upset of Duke. He was also the first Clemson player in history to make first-team Academic All-ACC. Head coach was Press Maravich.

The availability and kinds of entertainment on campus changed drastically after World War II and the end of military discipline. Social fraternities, the proliferation of cars, and the increasing availability of nearby entertainment that drew students away effected major changes in campus offerings. The university became the center not only for sports events, but also for national and international touring companies whose performances were attended by residents as far away as Greenville and Anderson. Robert Gaus' American Folk Ballet brought its musical show to Clemson's Field House (now Fike Recreation Center) in 1968.

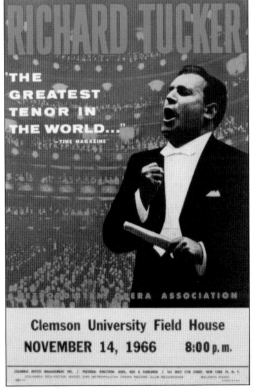

Richard Tucker, billed as "the greatest tenor in the world," performed at the Field House in the fall of 1966, where concert programs were presented before 1969. Thereafter, Littlejohn Coliseum served as the performance site until 1982, when the concert series moved to the remodeled auditorium of Tillman Hall. Groundbreaking ceremonies for the Brooks Center for the Performing Arts were held on April 5, 1991, and on January 22, 1994, the new center opened to students and the public with its first performance.

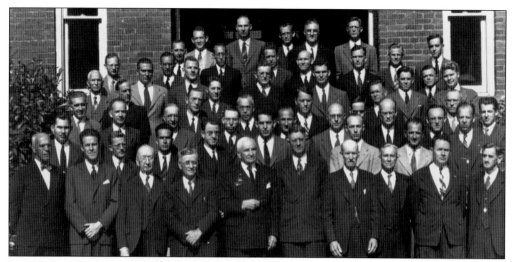

The quality of instruction in the humanities has been the yardstick for the caliber of universities since the beginning of higher education. Liberal arts curricula hone skills of logical, critical, and innovative thinking, clear and articulate expression of thought in written and spoken form, and a basic grasp of human relations that leads to success in all other disciplines. Clemson's College of Liberal Arts was born in 1969 as a derivative of the old College of Arts and Sciences. This photo of the Arts and Sciences faculty is from the files of Dean Henry E. Vogel, who headed the College of Sciences when it separated from the old college in 1971.

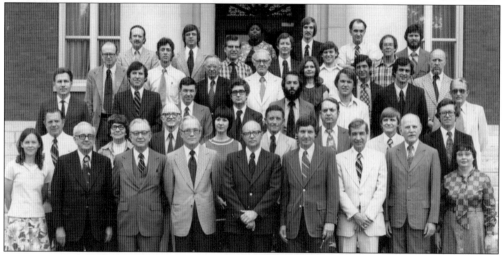

Initially, the College of Liberal Arts consisted only of the department of English and modern languages,and the department of social sciences. The English department members in this early 1980s photo are, from left to right, (first row) Joyce Medlin, Claude Greene, Arthur Fear, Richard Calhoun, Ronald Moran, Roger Rollin, Mark Steadman, Morris Cox, and Marilyn Nellis; (second row) B.N. Skardon, Corinne Sawyer, Albert Holt, Dixie Hickman, Louis Henry, John Simms, John McLaughlin, and Robert Hill; (third row) Victor Rudowski, Hallman Bryant, Ray Barfield, Harold Woodell, Bruce Firestone, Charles Egan, and Thomas Douglass; (fourth row) Richard Underwood, David Tilighast, Charles McGee, Claire Caskey, Joan McLaughlin, William Koon, Sterling Eisiminger, and John Idol; (fifth row) Raymond Sawyer, Charles Montgomery, Edward Willey, Terry Norton, John Hammonds, and Harry Curtis; (sixth row) Dee James, Frederick Shilstone, Frank Day, and Ronald Lunsford.

With co-education came the first dean of women, Susan G. Delony (shown), an Auburn graduate who later became dean of student life. The head of residence for the women's dorm was Mary Hood. Mrs. R.F. Poole, widow of the former president, was also employed as counselor for women. Among the many changes that came with the arrival of women on campus was the freshman "Rat" system. Once the female freshmen began wearing the caps and then ribbons, the system was abandoned.

The acceptance of women as active participants in important student activities was slow. Clemson's student publications show the gradual acceptance of women on campus. The *Chronicle,* first published in 1898, asks in a headline of October 1965, "What Sort of Man Writes the *Chronicle*?" The picture shows editor Garland Gooden, and the column at left names several other male contributors; however, Nancy Miller was the editor of *TAPS* in 1967, and *The Tiger's* editor from 1973 to 1975 was Nancy Jacobs. The yearbook first appeared in 1901 as *The Clemsonian*, and changed its name to *The Oconeean* and *The Annual of Clemson College*, until settling on *TAPS* in 1908. *The Tiger* was founded in 1907.

The *Chronicle*, a chiefly literary magazine, offered an early centerfold—the "greatest girlie feature ever seen in the *Chronicle*" of "local lovelies . . ."

. . . and recorded by Ronnie Nappier and Russ Meyers. The camerawork is the important feature (October 1965).

The same issue records the preoccupation of the sexes with the basics, contributed in cartoon-form by a "newcomer to the art department," Jim Carson.

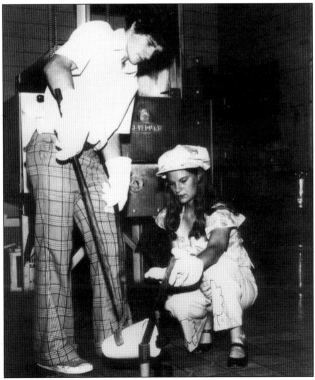

As expected, the novelty of co-eds on campus wore off and students settled down to the serious business of their education. These two are absorbed in their task in a ceramic engineering class.

Coeds Seek Court Posts

The Women's Residence Court shall have original jurisdiction over minor violations of student regulations concerning female students in or related to the Women's Dormitories. This court shall establish its own rules of procedure.

This procedure shall meet any requirements set forth in bill form by the Student Senate and shall be continuous and kept on file with the Attorney General in the Student Government room.

Cada Jenkins

A rising junior f om Summerville, Arcada Fleming Jenkins seeks re-election to the Women's Residence Court. Cada is majoring in English. Last year she was President of Women's Dorm No. 2, a member of the Angel Flight, and a member of Delta Theta Chi Sorority. This year she is Commander of the Angel Flight and Vice-President of Delta Theta Chi.

Betty Lynn

A second incumbent seeking re-election to the Women's Residence Court is Betty Chloe Lynn. A sophomore from Greenville, she is majoring in science teaching.

As a freshman, Betty was a member of the Wesley Foundation Council and is now serving as secretary-treasurer of the organization. She is also secretary of Omicron Zeta Tau Sorority.

Dolores Violette

Dolores Ann Violette, a sophomore majoring in applied math, also seeks election to the Women's Residence Court. Her home town is Lake City, S. C.

Dolores was a member of the Clemson Players last year. Her present activities include membership in the Light Brigade, the Newman Student Association, and the Women's Residence Court.

She commented that if elected, she hopes to help set a procedure for the court by organizing court records from previous years.

She also said, "When Clemson students in general awaken to the possibilities in the student government system, the student government will be more effective in achieving its goals. With the increasing percentage of women students, their support is becoming ever more vital. I think the coeds are both willing and able to take a responsible part in campus activities."

Cada Jenkins

Betty Lynn

Dolores Violette

Women also began to participate in student self-government. Cada Jenkins, Betty Lynn, and Dolores Violette sought election to the Women's Residence Court that handled minor infractions of rules in the dorms. The *Chronicle* story reveals the variety of curricula and activities the women pursued. English major Arcada Fleming Jenkins was president of the women's dorm no. 2 and commander of the Angel Flight. Betty Chloe Lynn, a science teaching major, was secretary-treasurer of the Wesley Foundation Council. Dolores Violette, applied math major, was a member of the Light Brigade and the Newman Student Association and was a Clemson Player as a freshman. A decade later, Patricia Warren served as president of the student senate.

Lee Hall's Rudolph E. Lee Gallery provided exhibit space for Clemson's students of art and architecture, served as a forum for the defense of theses, but increasingly also began to show the work of important artists outside the Clemson community. Today, the gallery presents exhibitions of outstanding regional, national, and international architects, and artists throughout the United States compete in the biennial National Print and Drawing Exhibition held at Clemson.

This drawing class was held in the Lee Hall courtyard.

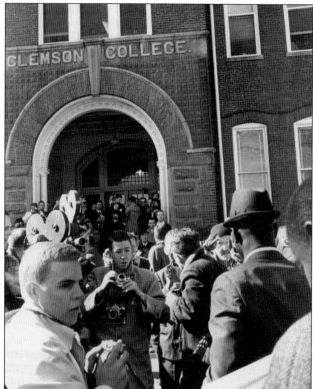

Charlestonian Harvey Bernard Gantt, having previously applied for admission to Clemson, was studying architecture at Iowa State University in Ames when he reapplied at Clemson in January 1962. Again denied admission, Gantt's attorneys filed suit in federal court and, on appeal, won admittance for the first black student in Clemson's history.

Lee Hall's Gunnin Library is shown here. The architecture building, constructed c. 1958, has maintained its original space with only marginal renovation or addition.

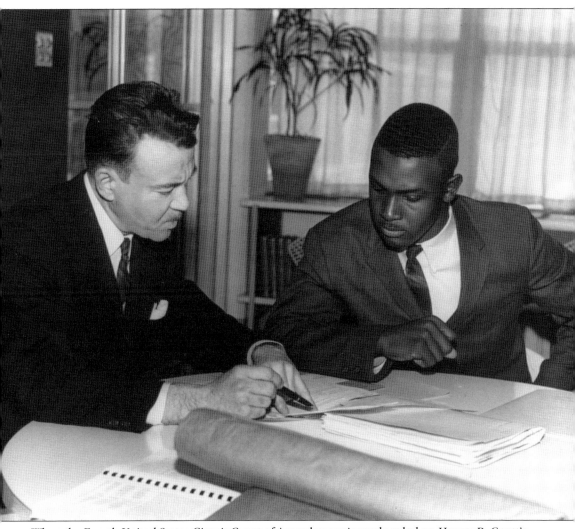

When the Fourth United States Circuit Court of Appeals unanimously ruled on Harvey B. Gantt's case, directing Clemson on January 16, 1963 to admit Gantt by February 1, Clemson was already busy preparing for the event. Life trustee Charles E. Daniel had declared, "the desegregation issue cannot continue to be hidden behind the door," and persuaded the business community that raising the economic and educational status of South Carolina's black population "would raise the whole economy of the state." With Gov. "Fritz" Hollings and top government officials in agreement, Clemson prepared for the day of Gantt's admission. Maintaining law and order was paramount. Officers were told to "tolerate verbal abuse" or similar harassment, but to prepare for quick removal of lawbreakers to assigned detention areas. SLED, college security, neighboring sheriffs, and highway patrolmen were placed on campus to assure order. On the day Gantt entered Tillman Hall to register, assisted by senior Robert Scott from Fairforest, South Carolina, some 200 students and 186 reporters witnessed Gantt's registration. After telling the press, "I just want to get an education," Gantt went to his dorm room and then to a conference with Dean Harlan McClure (above). Harvey B. Gantt graduated from Clemson on May 29, 1965 with a B.A. in architecture.

Members of the Student League for Black Identity (SLBI) are shown on the lawn of the Calhoun Mansion. The organization was founded with 42 members in the fall of 1968 "to promote black awareness through encouragement of black history courses, the study of black culture, and the black man's relationship with his society" (*The Tiger,* 12/6/68). Charles E. Williams, an electrical engineering major, was its first president. History professor W.F. Steirer Jr. served as adviser and originated Clemson's course on the *History of Black America*. Williams noted that the SLBI would "request the introduction of other black courses to Clemson's curriculum."

Ernest McPherson Lander (left) and Charles M. McGee sign a copy of their book *Floride Clemson, 1842–1871: A Rebel Came Home* for Frank J. Jervey. Olivia Jackson McGee illustrated the volume. "Whitey" Lander has written more than a dozen books relating to Clemson's and South Carolina's history and economics.

The quest for lighter, yet stronger and more protective materials demanded by an increasingly competitive packaging industry led to some innovative teaching and scientific testing techniques. The photo shows Prof. Douglas W. Bradbury with the winner of the "egg drop contest."

In May 1969, Craig Mobley became the first black student athlete to sign an athletic grant-in-aid with Clemson University. The 6-foot guard, named most valuable player on Chester High's basketball team, was also MVP in the Eastern AAA Conference in 1968–1969, leading all scorers in the conference for two years. A multi-talented, academically outstanding student, Mobley was president of the National Honor Society and served as pianist and organist of Calvary Baptist Church. He came to Clemson to study chemical engineering.

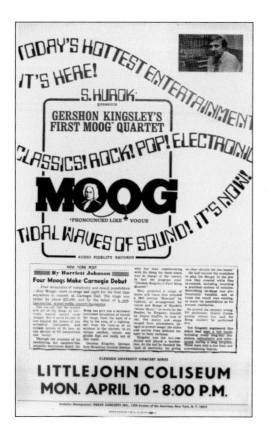

The Littlejohn Coliseum built during the Edwards administration was not only used for sports performances, but also offered increasingly sophisticated cultural events to Clemson students. Inventor Robert Arthur Moog (Ph.D. Cornell University, 1965) introduced a prototype of his Moog musical synthesizer in 1964 and began his collaboration with composer and organist Walter Carlos to produce an exciting new sound palette. The electronic instrument became a household word through the best-selling record *Switched on Bach* in 1969. A performance at Clemson around that time was cutting-edge entertainment.

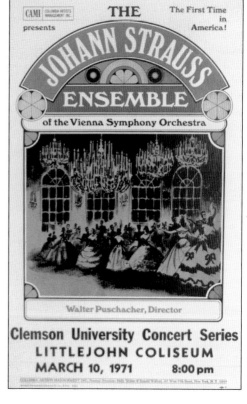

In the spring of 1971, the Johann Strauss ensemble of the Vienna Symphony brought international flair to the Clemson campus with the famed Viennese "waltz king's" exuberant melodies performed by a world-class orchestra.

The women's varsity athletic programs were started at Clemson in the academic year 1975–1976 with swimming, basketball, and tennis teams, which proved immediately successful. In their second year, the Lady Tigers could claim their first All-American, Chris Daggitt.

Cross-country running, volleyball, field hockey, and fencing were added next to Clemson's women varsity teams. Architecture student Tina Krebs from Hobak, Denmark was a three-time National Championship winner with indoor track records of 2:28:58 for the 1,000 yard in 1983, the 1,500m (4:17:45) in 1985, and the mile (4:40:82) in 1986.

Head Coach Dr. I.M. Ibrahim

Dr. I.M. Ibrahim has established himself as one of the top coaches in the history of collegiate soccer.

Guiding Clemson to two national championships in the decade of the '80s, Ibrahim became only the sixth coach to win 300 or more games in a career when his team defeated Georgia State, 2-0 on October 5, 1988. Now with 375 wins, he is nearing the 400 mark and ranks fifth in collegiate history in total victories.

Ibrahim led Clemson in 1987 to s second national title in four years. The team finished with a 4-1 record in the ACC and was the 23rd of the 24 teams selected the NCAA playoffs, but the Tigers made an incredible run in late ovember and early December. In a year characterized as a ebuilding season, Ibrahim marched his team, that included six tarting freshmen, to the pinnacle of the collegiate soccer world — e national title.

Dr. I.M. Ibrahim is the winningest coach in what has been the remier soccer conference in the nation over the last few years. Vinning over 78 percent of his games the last 27 seasons, 12 ACC tles and two national championships, Ibrahim is one of the most espected coaches in the nation. A history of Clemson soccer is a istory of Ibrahim's career — he is the only soccer coach ever at lemson. Perhaps the most revealing of the Ibrahim-Clemson ccomplishments, other than the two national titles, is that 1993 as the 19th year Clemson had finished in the final top 20 poll.

Ibrahim has coached exactly 500 games, but his finest hour ok place in a 2-0 win over San Diego State at Clemson in 1987. e stood on top of the college soccer world as his Tigers won their econd national championship in front of 8,332 fans at Riggs Field.

Ibrahim guided his team to three road victories in the first three rounds, including an upset of number-one ranked Indiana in the Great Lakes Regional finals. It was Indiana's first home NCAA Tournament loss ever. Clemson was rewarded for the road efforts by being chosen to play host to the Final Four. In the semifinals, the Tigers pounded North Carolina 4-1 to set up the championship match against San Diego State. There, the Tigers and Ibrahim claimed their second national title in four years.

Another highlight for Ibrahim came in December of 1984 when he led the Tigers to a 2-1 victory over two-time defending NCAA champion Indiana to claim the '84 National Championship. The road was not an easy one, though, as Clemson defeated the top four seeds in the field, marking the first time in the history of any NCAA tournament in any sport, that a team had beaten the top four seeds to win an NCAA title.

Ibrahim ranks in the top five in the country in terms of total career wins and winning percentage. His 32 NCAA tournament wins are also a top five figure. In fact, Clemson has the fifth best winning percentage with a .667 mark in the NCAA soccer tournament. He is by far the winningest coach in ACC history and has the best career winning percentage among all coaches in the history of Clemson athletics who have coached at least five years.

Since Coach Ibrahim began the program in 1967, his teams have compiled a record of 375-95-30 (.780), won 12 Atlantic Coast Conference championships and made 17 appearances in the NCAA tournament. It is easy to see why the Clemson mentor is one of the most highly regarded coaches in the United States.

During the 1972-80 period of Tiger domination of the ACC, Clemson posted an incredible record of 40-0-2 in league action. The Tigers did not suffer a loss in ACC competition from 1972-80. During that span, five of Ibrahim's teams were undefeated during the regular season (1972, 1973, 1976, 1977, 1978).

In those 17 appearances in postseason action, Ibrahim has watched his teams compile a record of 32-16. The Tigers have

Ibrahim has guided Clemson to two national titles in 1984 and 1987.

Soccer, a world-class sport that gained favor in the United States relatively late, was introduced to Clemson fans by Dr. I.M. Ibrahim, the "Father of Southeastern Soccer." Ibrahim came to Clemson in 1964 to earn an M.S. and Ph.D. in chemistry. After starting Clemson soccer in 1967, he became head soccer coach when the team achieved varsity status. "Coach," as he is affectionately called, led Clemson's players to two NCAA championships. In 1984, Clemson celebrated its first-ever national championship in soccer, and in December 1987 a crowd of 8,332 witnessed Clemson's second NCAA win, defeating San Diego State 2-0 at the newly constructed Clemson soccer stadium on historic Riggs Field. Ibrahim's record of winning over 78 percent of his games in the last 27 seasons, 12 ACC titles, and two national championships makes the Clemson alumnus the "winningest" soccer coach.

The Clemson Tigers were featured on the cover of *Sports Illustrated* after winning their first National Championship in the 1982 Orange Bowl with a 22-15 win over the Nebraska Cornhuskers. Danny Ford coached the team to its third perfect season in history.

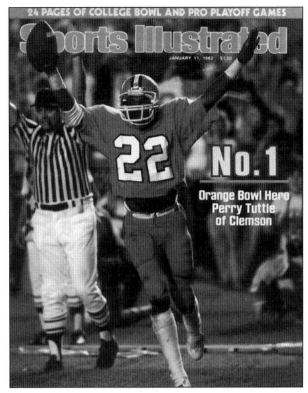

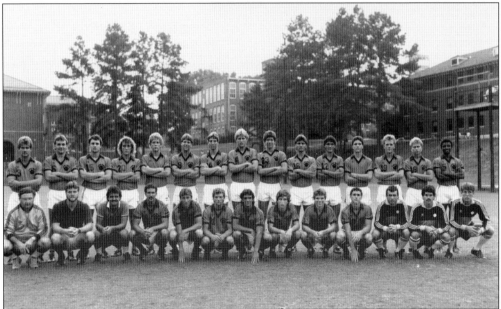

The Tigers won their first NCAA championship in soccer with a 2-1 win over Indiana in the Seattle Kingdome in 1984, defeating the number one, two, three, and four seeded teams in the tournament. They were the only team in NCAA history, regardless of sport, to accomplish that. Adubarie Otorubio (top right) is Clemson's only three-time All-American. Coach I.M. Ibrahim is in the first row, left.

The academic year 1989–1990 saw numerous firsts for the Clemson basketball team. The Tigers won their first-ever Atlantic Coast Conference regular season championship, posting a 10-4 record in a season in which ACC teams Duke and Georgia Tech both advanced to the Final Four. Both Dale Davis and Elden Campbell were named first-team All-ACC players, a first for Clemson. Head coach Cliff Ellis was named ACC Coach of the Year.

Bruce Murray (right), first-team All-American in 1985 and 1987, had the winning goal in three NCAA tournament games for the Tigers in 1987 and is the first player in Clemson history in the 40-40 Club (over 40 goals and 40 assists in career). Winner of the Hermann Award (1987), ISAA National Player-of-the-Year (1987), and numerous other awards and honors, Murray was the all-time leading scorer for the National Team when he retired.

This *TAPS* 1969 photo shows a pole vaulter's leap of faith to overcome a seemingly insurmountable obstacle. At the beginning of the new millennium, Clemson University is a fully accredited institution with an enrollment that has grown to more than 17,000. Situated on 1,400 acres on the banks of Lake Hartwell, Clemson has awarded well beyond 112,000 degrees, including more than 25,700 master's degrees and doctorates. In the center of campus the Calhoun mansion presides over a diverse state-of-the-art, scientifically and technologically oriented research institution, with national and worldwide programs, statewide extension and experiment stations, 41 computer labs, a beautifully maintained campus, and South Carolina's Botanical Garden. Thomas Green Clemson would be proud that his vision became Clemson's history for the future.

Epilogue

Any book must fall short of expressing the significance of Clemson—this one especially so because of the limitations of time and space placed upon it—yet many have contributed to make it as accurate as possible. Because of the large number of Clemson's alumni, students, faculty, staff, and administrators who have given generously of their time and knowledge, resources and skills, or who have lent their treasured photos, this book can aptly be called a family album. Still, errors will invariably have occurred. The author asks for the reader's gracious indulgence and solicits information on factual errors so that they may be corrected in future editions.

At every end there is a new beginning.

BIBLIOGRAPHY

Benjamin, Laura L. *Clemson University College of Engineering. One Hundred Years of Progress.* Clemson University, 1989.

Bryan, Wright. *Clemson: An Informal History of the University, 1889–1979.* Columbia, S.C.: R.L. Bryan Co., 1979.

Hale, Rebecca McKinney. *Clemson Agricultural College: Years of Transition, 1925–1929.* Clemson University, M.A. Thesis, 1984.

McKale, Donald M., Reel, Jerome V., et al; Palmer, Kate Salley, illustr. *Tradition: A History of the Presidency of Clemson University.* Macon, GA: Mercer University Press, 1998.

Lander, Ernest McPherson Jr. *The Calhoun Family and Thomas Green Clemson: The Decline of a Southern Patriarchy.* Columbia: University of S.C. Press, 1983.

Littlejohn, Mary Katherine. *Tales of Tigertown. Anecdotes of a Lifetime on the Clemson Campus.* Clemson, S.C., 1979.

Louden, Robert M. *A Varsity Sports Center for Clemson University.* Clemson University, M. Arch. Thesis, 1980.

Mellette, Frank M. *Old Clemson College: It Was a Hell of a Place.* S.L.: s.n., 1981.

Schaffer, Alan. *Visions: Clemson's Yesteryears, 1880–1960s.* Louisville, KY: Harmony House, 1990.

Articles and Pamphlets:

Barker, James F. *Sacred Soil of Bowman Field.* Clemson World, Vol. 53, No. 3 , 2000.

CLEMSON MEMORIAL SERVICE, December 7, 1944. Clemson, S.C., 1944.

Glenn, H.E. *Plaques, Cornerstones and Other Identifying Markers on Clemson College Buildings.* Clemson, S.C., 1958.

Patterson, James Kennedy. *Commencement Address to the Graduating Class of Clemson Agricultural College.* Memorial Hall: June 13, 1911.

Poole, Robert F. *Thomas G. Clemson (1807–1888). His Influence in Developing Land-Grant Colleges.* New York: The Newcomen Society, 1957.

Ritchie, James; Mills, Mary Leighton. *The Main Building, in Later Years Named Tillman Hall, Clemson University.* Clemson, S.C., 1960.

Sweeny, James O. *The Plaques in the Cadet Life Garden in the South Carolina Botanical Garden at Clemson.* Clemson, S.C.: Clemson University, 1999.

Discover Thousands of Local History Books
Featuring Millions of Vintage Images

Arcadia Publishing, the leading local history publisher in the United States, is committed to making history accessible and meaningful through publishing books that celebrate and preserve the heritage of America's people and places.

Find more books like this at
www.arcadiapublishing.com

Search for your hometown history, your old stomping grounds, and even your favorite sports team.

Consistent with our mission to preserve history on a local level, this book was printed in South Carolina on American-made paper and manufactured entirely in the United States. Products carrying the accredited Forest Stewardship Council (FSC) label are printed on 100 percent FSC-certified paper.